T0131496

Reflections

Australian Artists Living in Tokyo

Sachiko Tamai

BALBOA
PRESS

A DIVISION OF HAY HOUSE

Balboa Press books may be ordered through booksellers or by contacting:

Balboa Press
A Division of Hay House
1663 Liberty Drive
Bloomington, IN 47403
www.balboapress.com.au
1 (877) 407-4847

Because of the dynamic nature of the Internet, any web addresses or links contained in this book may have changed since publication and may no longer be valid. The views expressed in this work are solely those of the author and do not necessarily reflect the views of the publisher, and the publisher hereby disclaims any responsibility for them.

The author of this book does not dispense medical advice or prescribe the use of any technique as a form of treatment for physical, emotional, or medical problems without the advice of a physician, either directly or indirectly. The intent of the author is only to offer information of a general nature to help you in your quest for emotional and spiritual well-being. In the event you use any of the information in this book for yourself, which is your constitutional right, the author and the publisher assume no responsibility for your actions.

Any people depicted in stock imagery provided by Getty Images are models, and such images are being used for illustrative purposes only.
Certain stock imagery © Getty Images.

Print information available on the last page.

ISBN: 978-1-5043-1757-3 (sc)
ISBN: 978-1-5043-1758-0 (e)

Balboa Press rev. date: 04/29/2019

Contents

Foreword

\intachiko Tamai OAM has made yet another wonderful contribution to Australian art and diplomatic history by putting together a book about Australian artists who worked in Tokyo in the 1980s and 1990s. The many artists who were able to work in Japan in these decades include those who were fortunate enough to be selected to use the Australia Council's Artist-in-Residence Studio in Tokyo which opened in 1987. Between that time and the Studio's closure in 2016, it was occupied by a wealth of Australian painters, sculptors, photographers, 3D and multi-media artists. Some of their stories of deep personal engagement with Japan make up much of this book. It was a remarkably fertile period and the extended residencies of many established and emerging Australian artists provided enormous enrichment to them from their intense intersection with both the traditional and vibrant contemporary cultural resources of Tokyo and Japan more widely.

In Australia we give far too little respect to the voices of our creative artists and we pay far too little heed to our own cultural history. Perhaps we are still too close to our pioneer ancestry and still struggling to find a more sophisticated national identity. We are very fortunate, therefore, that Sachiko Tamai has taken on this important challenge to record the experiences of Australian artists working in Japan over the decades of this study. Our growing links with Asia, and North East Asia in particular, give these pioneering exchanges additional relevance.

Sachiko Tamai worked as the Senior Cultural Officer for the Australian Embassy in Tokyo from 1986 to 2000 and following that worked for the Australia-Japan Foundation. I am confident that she met and assisted almost every one of the Australian artists who took up residencies in Tokyo across the period of this book and is therefore the perfect person to initiate

and develop the collection of these valuable studies. In my experience, her close personal networks across both the Australian and Japanese visual and performing arts scenes were unequalled, and she was always ready to put these networks to use for Australia's advantage.

I personally recall with enormous gratitude her great work in setting up the 1986 tour of the Playbox Theatre Company's production of *King Lear* to the Tokyo Globe Theatre and the Aichi Arts Centre in Nagoya. It was an extraordinary personal experience for me to be part of this tour. Playing to the very sophisticated Tokyo audience was a career highlight. It is not surprising, therefore, that the visual artists, who had extended time on their residencies to experience Japan, write with passion and persuasion about the impact of this country on their continuing work.

Like so many of us, Australia owes Sachiko Tamai a debt of gratitude and bountiful congratulations on the production of this book.

<div align="right">

Carrillo Gantner AO
Chairman
Sidney Myer Fund

</div>

Acknowledgements

One day in August 2016. Emiko Namikawa and I, as manager/consultants, were in the VACB Tokyo Studio for its closing at the end of August. It looked the same as usual, but there would be no more visiting Australian artists. After Chris Headley, the last artist–in–residence, left early August, we had to clear the studio to finalise the rent. When we asked the Australia Council how to handle the Council's property, the answer was: "All should be disposed of. Nothing should be left in Tokyo", which sounded natural and correct for the office closure of a governmental institute and we did not ask any further about the intellectual tradition and heritage of over 30 years with more than 100 artists.

Looking at the inventory we reported annually to the Council, we checked and chatted and flashed back to the time of setting up the studio in 1987. We wondered if anybody cared about the story of that time and whether this history should be preserved in some way, particularly when thinking of the loss of people who could no longer share their memories, namely Akio Makigawa, Goji Hamada and John Davis.

Everything has been changing so quickly and a robot works better than me in some areas. Everything is handled and organised so quickly and smoothly by computers. Everything shall be lost or forgotten for good if it is not preserved in digital memory. There are, however, many things including individual names and the invisible connections between people and others that cannot be preserved on the internet, but are still vital in influencing human activities at different levels of society, between different ages and with different spirits. Things that happened in the past are easily forgotten despite having had a vital impact on us.

This book is a collection of written voices from the artists who had experienced staying in Japan, including those in the Australia Council's

Tokyo Studio, and whom Emiko and I could communicate with personally. I asked my friends who could tell me about that time to contribute their writings together with mine and Emiko's memories. This collection of essays and interviews with artists illustrates a part of the Australian art scene in Japan in the 1970s, 1980s and 1990s.

I hope readers will be able to enjoy such stories which are related to the contemporary art scene in Australia. I did not note the date when the artists wrote their contributions and there may be a time lag in their accounts of what they are doing now and what their future plans are. I regret to say that I could not include any images of their works sent to me at my request. All are beautiful and still remain in my mail box.

I hope this book will enable readers to reflect on past times with an easy and comfortable feeling and return to contemporary society with some new discoveries. I hope that in the future academic research will follow up with analysis of the time illustrated in this book and the artists who were a part of that era.

Upon the occasion of this publication I would like to extend a big thanks to all the artists who contributed, also to Judy Annear for encouraging me all the time, and Alison Tokita for always supporting me. Without the editorial assistance of Mark Justin Rainey, I could not have reached this goal. Special thanks also to Tomoko Ichitani, Setsuko Tanaka, Neil Clarke and Angel and all the other staff of the Balboa Press for their kind help.

<div align="right">Sachiko Tamai, November 2018</div>

Part 1

The Dawn of Australian Art in Tokyo

The Dawn of Australian Art in Tokyo

Sachiko Tamai

"*A*ustralian Culture?", "What is it?", "Any culture in Australia? Ah, Sports." etc. This is how many of my friends reacted when I took up the post of Senior Cultural Officer at the Australian Embassy, Tokyo. That was June 1986. Most Japanese had a general image of Australia as being a country of kangaroos and koalas. I found I was a bit different as I loved Australia and Australian people ever since my late twenties when I had worked in Melbourne as a translator and announcer for Radio Australia on Japanese language broadcasts that introduced Australia to Japan with scripts provided by the Australian Broadcasting Commission.

1986 was a hectic time for me in my new role at the Embassy. There were official and unofficial visits relating to the Bicentennial Authority, World Expo 88 in Brisbane, the 1988 Adelaide Festival and the Biennale of Sydney. This was on top of my routine daily work in the Embassy which was supervised by the Tokyo Director of the Australia-Japan Foundation (AJF). The Director of the AJF was not a diplomat so my post was dually supervised by the Counsellor of the Embassy.

I was very lucky that Sachiko Yamaya joined my office as a secretary, having previously worked with the First Secretary in charge of Culture in the Embassy, and could pull out files from the cabinet behind me whenever I was puzzled and needed information. Although my post was new, things had been continuing on in the cultural area as they had always done. One of the priorities in my list of things to do was to establish an Artist-in-Residence (AIR) program, but even Yamaya-san did not know many details about the proposed project. Reflecting back on this time,

1

it was apparent that the people most involved were Australian artists and their supporters who were arguing in favour of the importance and significance of such a program. They had been discussing the program with the Australia Council which, up to that point, had no representation in the Embassy. I was very positive about the program since I was very much impressed by the Australian desire to support its artists. I visited the owner of the proposed AIR studio on behalf of the Australia Council to discuss the rent and worked to set up the Tokyo Studio where the very first resident artist, Liz Coats would start her life in Tokyo in January 1987. The program terminated in August 2016. More than 100 Australian artists stayed in the Tokyo studio and the Australia Council was a pioneer of AIR activities which are now very popular in both the public and private art sectors in Japan.

Shortly after I took up the post in the Embassy, a staff member from the foundation of an Australian corporation visited my office seeking the possibility of a Japanese tour of its Charles Blackman collection. I made an appointment with the Chief Curator of the Tokyo National Museum of Modern Art to get his advice. I went to meet Iwasaki-san with the catalogue. He did not show much knowledge about Charles Blackman. I clearly remember what he said. "I have asked my colleagues in the Museum before this meeting, but I am ashamed to say nobody had any knowledge about Australian art and had no contact with Australia to date." Later when my office began to manage the cultural budget, I proposed to Canberra that we commence a program inviting Japanese art curators to Australia in order to introduce them to Australian art galleries and Australian culture in general. Based on the Australian value of fair play, I not only asked the Japanese Cultural Agency (JCA) to nominate a Japanese curator to send to Australia, but also to nominate an Australian curator to visit Japan. The visit by an Australian art curator to Japan was organised by the Japan section of DFAT (Department of Foreign Affairs and Trade) using a discretionary budget. Hideo Tomiyama, then deputy Director of the Tokyo National Museum of Modern Art, was the first Japanese curator nominated by the JCA. His impression following a week-long trip to Australia was that there was a good collection of British paintings in major Australian galleries.

During this time, I was very lucky and happy to work with Gillian Walker in Canberra over the phone and email, not only on this program, but also on others. Her good advice in relation to the situation in Australia had a positive impact on my planning and decision-making as an officer based in Tokyo. She had previously worked in the embassy in Tokyo and later became the Director of the AJF in Canberra.

My office began to receive many visits by people from the Australian art sector who were seeking opportunities in Japan and Japanese artists who were seeking opportunities in Australia. My priority was to introduce Australian art and culture to a Japanese audience with the support of Australian public sector institutions, but I also wanted to develop a mutual understanding between artists both in Australia and Japan through private sector connections. I began to see how difficult it was for Australian art to penetrate the art market in Japan. I also became aware of the different social systems and ways of thinking between Australia and Japan.

Every three months from 1987 onwards Australian artists that had been selected by the Australia Council took up residency in the studio in Tokyo and many of them also visited the Lunami Gallery in Ginza which had become a sort of mecca for visiting Australian artists. Due to the big success of the 1983 and 1985 *Continuum* exhibitions, the Lunami Gallery was often the first gallery for them to visit in Tokyo. Emiko Namikawa, Director of the Lunami Gallery which was closed in 1998, was well known among Australian artists as the organiser of *Continuum '83*, an Australian contemporary art exhibition across more than 10 galleries in Ginza in 1983 and two years later she would be involved in Japanese contemporary art exhibitions in Melbourne. In Alison Broinowski's *The Yellow Lady* (Oxford University Press, 1994), Emiko Namikawa, Hamada Goji, John Davis, Stelarc, Maryrose Sinn, Peter Callas, Akio Makigawa and Ken Scarlett are referred to as the 'Continuum' group of artists who "began an exchange of exhibitions which broke the rules and rejected national prescription for art." I noted from Emiko's writing that Judy Annear was approached by the group, but she could not get involved due to her commitments at the Art Space, Sydney.

Those landmark international exchanges in the early 1980s provided a strong base for the establishment of the Australia Council's Tokyo Studio. Later, I would recall that I had actually attended the opening reception

of *Continuum '83* in the garden of the Australian Embassy thanks to an invitation from my friend, Fujiko Nakaya, but at that time I wasn't working in the art sector and was only enjoying Australian culture through this one-off event.

I am very much interested in the fact that back in the 1970s Stelarc performed in Tokyo. The Australian artist had penetrated the Japanese art scene in the 1960s and 70s when the Japanese art world was strongly influenced by American hippie culture and American pop culture. Stelarc's performances in Tokyo partially opened the Japanese art scene's eyes to other parts of the world and along with Japan's economic growth provided much of the energy and excitement behind the later international exchanges in the 1980s. In Japan, Australia was recognised as a Western country, but not a European country. It would not be wrong to say that in Japan at that time, fine art was believed to be European while contemporary art was seen to be American. I do not want to argue this matter, but I was once questioned if there was anything Japan could learn from Australian art that was different to established European countries when I proposed organising an Australian art performance to a government level institute in Japan. That was the reality in the 1980s in Japan. That's why it is so significant to note how Australian artists and curators left strong building blocks in Japan in the 1970s and 80s. A number of Australian artists also came to Japan to learn Japanese art, such as pottery, although they often did not showcase Australian art in particular at that time.

I refer to the 1980s as the 'Dawn of the Australian Art in Tokyo'. At the same time, it should be noted that in the very early light of this Dawn, there was the *YOIN* exhibition of Japanese contemporary art in Melbourne. The organisers and artists included Akio Makigawa and Ken Scarlett who became strong supporters of the art exchanges between Australia and Japan. Noelene Lucas was a student assisting the *YOIN* Melbourne organisers and in 1987 she was selected to be an artist-in-residence at the Tokyo Studio.

Morning Arrives for Australian Art in Tokyo

The *Contemporary Australian Art* exhibition was held at the Museum of Modern Art in Saitama from 9 October to 16 December, 1987. The

exhibition coincided with celebrations commemorating the three-year anniversary of the official sister-relations between Saitama Prefecture and Queensland, Australia. Michel Sourgnes of the Queensland Art Gallery selected nearly 30 works of contemporary art from Australia to be shown in Saitama, including mixed media installations.

Edge to Edge, the Australian Bicentennial Authority's contemporary arts exhibition in Japan, was held at the Osaka Contemporary Art Center between May and July 1988. Over the following year, it then toured to the Hara Museum of Contemporary Art Annex, the Nagoya City Art Museum and the Hokkaido Museum of Modern Art. The Australian Bicentennial Authority had arranged a number of events across the world through its "Australia to the World" and "World to Australia" programs and the *Edge to Edge* exhibition was arranged under the "Australia to the World" program. Judy Annear was the lead curator from Australia, working with Akira Tatehata who was then curator at the Osaka Contemporary Art Center. They were then joined by the curators Takeshi Kanazawa and Tomoyoshi Sato, from each of the venues, to make the final selection of artists from Australia whose works would be shown in the travelling exhibition.

After 1987, Australian artists were a constant presence in the Tokyo Studio through the AIR program organised by the Australia Council. *Tokyo Connection* was an exhibition held at the Heineken Village between 1 and 17 June, 1990 that showcased the work of the first thirteen artists who had been residents in Tokyo Studio. The Senior Cultural Officer at the Australian Embassy had heard that the Heineken Village could be used as a gallery space prior to its demolition and she discussed the idea with some of the artists who had stayed in the Tokyo Studio and proposed the exhibition to Noel Frankham, Director of the Visual Arts / Craft Board at the Australia Council. An initial, negative response was followed up by more persuasion from the Tokyo side and backed by the enthusiasm of the artists involved. Noel contracted temporary staff to start organising the exhibition from Australia and Emiko Namikawa set up a committee in Tokyo. I recall receiving a phone call at a very late stage from a naïve staff member of the Tokyo Metropolitan Government who had not realised that Heineken was a beer company and stated that he could not support a beer company. I persuaded him that the exhibition should still

go ahead. Emiko obtained a cultural grant from the Tokyo Metropolitan Government and I explained that the space was to be used for Heineken's philanthropic activities. All the artists came back to Tokyo from Australia for the exhibition and saw the venue and voluntarily painted the walls white before hanging their works. It was interesting to see each artist's memories of Tokyo in the works displayed.

As interest in contemporary Australian art increased, more and more exhibitions took place throughout Tokyo. Clinton Garofano was selected from the Tokyo Studio residents and invited to exhibit his works in a solo show at the Spiral Hall, Tokyo. The exhibition was held from the 22 February to 10 March, 1991. *Art Knits*, an exhibition on contemporary Australian knitting design, was held at the Marimura Art Museum in Omotesando, Tokyo between 17 October and 30 October, 1989. The Marimura Art Museum followed this up with an exhibition on contemporary Australian fashion between 28 June and 13 July, 1990. The Axis Gallery hosted an exhibition on contemporary Tasmanian craftwork between 19 and 22 October, 1990. On the other side of this artistic and cultural exchange, the exhibition *Zones of Love: Contemporary Art from Japan* was briefly shown between 18 May and 6 June, 1991, at the Touko Museum of Contemporary Art in Tokyo, before the exhibition travelled to Australia.

Two Hundred Years of Australian Painting was a major exhibition of Australian art held at the National Museum of Western Art, Ueno and the National Museum of Modern Art in Kyoto in 1992. The exhibition had been proposed by the Australian Embassy to Seiro Maekawa, then Director of the National Museum of Western Art, Tokyo. The AJF funded and organised the exhibition alongside the Nihon Keizai Shimbun. At that time it was customary to involve a media company in such a major exhibition, whether a television company or a newspaper, and the Nihon Keizai Shimbun not only generated publicity for the exhibition but also worked on raising funds. Barry Pearce from the Art Gallery of New South Wales worked with Haruo Arikawa, curator of the Museum of Western Art, to select paintings for the exhibition. Arikawa travelled extensively to galleries in Australia to make the selections. *Two Hundred Years of Australian Painting* was shown from 28 April to 28 June, 1992 at the

National Museum of Western Art, Tokyo and from 14 July to 6 September, 1992 at the National Museum of Modern Art, Kyoto.

There were more Australian artists coming to Japan to participate in festivals or international group exhibitions. The Celebrate Australia 1993 festival was organised by the Australian Embassy in Tokyo and included a contemporary art exhibition, *Inner Land*, which was curated by Emiko Namikawa.

Japanese society was changing and, along with the art world, was loosening its boundaries in often complex ways. Those involved in the contemporary art scene were trying to find and create meaning in such complicated times as the 20th century drew to a close.

My relations to the Australian artists who stayed in Tokyo Studio or other AIR programs are many and deep. I have noticed that in the 2010s, incoming artists are much more familiar with Tokyo and have an easier time navigating life in the city through the use of smart phones and IT devices. I can recall how those artists coming to stay in Japan in the 1980s encountered difficulties and could not rely on the internet or mobile phones. Most of the artists mentioned that living in Japan is quite different from a short visit. I have sent out questionnaires to those friends I have lasting connections with about their life in Tokyo. Their responses and reflections about Tokyo and Japan form the second part of this book.

The Dawn of Aboriginal Art in Japan

The exhibition, *The Art of the First Australians*, was held at the Kobe City Museum from 26 July to 31 August 1986. It was organised by the Museum and the Kobe Shimbun to commemorate the twinning of Kobe and Brisbane in 1985. The exhibition displayed Aboriginal art as well as artefacts from the National Museum of Ethnology in Osaka. This was followed by the *50,000 Years of Hunters and Spirits* exhibition at the National Museum of Ethnology, which was a collaboration between the museum and the Sankei Shimbun, Osaka.

As more Japanese people visited the Australian Outback in the 1980s, there were attempts to organise personal exhibitions of Aboriginal paintings, crafts and bark paintings. I met some of these people when they visited my office at the Embassy.

It is recognised in the Japanese art world that the first Aboriginal art exhibition was held in 1992 at the Kyoto and Tokyo National Museums of Modern Art. The curator was Shinji Komoto of the Kyoto National Museum of Modern Art working with the Western Australian Art Gallery. *Crossroad – Toward a New Reality: Aboriginal Art from Australia* was held from 22 September to 8 November, 1992 in Kyoto and toured to the Tokyo National Museum of Modern Art from 17 November to 20 December, 1992. Aboriginal artists were invited to give talks at both venues.

Through my experiences as the Senior Cultural Officer in the Embassy and working on Aboriginal art exhibitions, I could refresh and learn new ways of thinking. For instance, one page of the exhibition catalogue for *Crossroad – Toward a New Reality* was intentionally left blank due to an objection by one artist to printing his work for the public. The work itself was on display in the exhibition but printing an image of the work was regarded as a problem as it revealed a secret of his tribe. What we take to be art is an important issue and it is important to pass on these meanings to the next generation.

At work in my office in Tokyo, Gillian Walker and I had to be sensitive in our roles as governmental officers when talking with Aboriginal artists. I was sending requests from Japan and Gillian was coordinating the matter with agents in Australia. I initially took advice from the National Museum of Ethnology, however such institutions were sometimes viewed with mistrust by Aboriginal artists due to historical and personal experiences of anthropologists conducting research on Aboriginal peoples.

In the 21st Century, such a story is now an old story. The exhibition *Invitation to the Dream Time: Aboriginal Australian Art* was held at the Tochigi Prefectural Art Museum from 1 July to 2 September, 2001. Australian Aboriginal art is now well established in the art industry and recognised throughout the world. When he was the Director of the National Museum of Art in Osaka, Akira Tatehata set up a solo exhibition of Emily Kngwarraye's work. He decided to show Aboriginal Australian art at the Museum while staring and gazing at Emily's work at the National Gallery of Victoria. The exhibition of Emily Kngwarraye's work was held at the Osaka National Museum of Art from 2 February to 13 April 2008 and then toured to the National Art Center in Tokyo from 28 May to 8 July 2008. This was curated by the National Museum of Australia, Canberra

and supported by the Yomiuri Shimbun in Japan. This exhibition is viewed as a successful Australian art exhibition in Japan, drawing an audience of 35,000 in Osaka and 117,000 in Tokyo. A friend of mine who is a professor at Keio University and a well-established reviewer of contemporary art told me that he was very moved by Emily's work: "There is such as strong artist whom we did not know!".

Art Exchanges between Australia and Japan

Emiko Namikawa

At the beginning of the art exchanges between Australia and Japan, at the start of the 1980s, I met Maryrose Sinn, an Australian sculptor who spent nearly a year in Tokyo in 1981. She walked around many galleries in Tokyo's Ginza district every week and dropped by at my gallery, Lunami Gallery, with some Australian catalogues. Before returning to Australia she held a solo exhibition at my gallery and I said, "I'm wondering if we could have an exhibition of contemporary Australian art here in Tokyo someday." She mentioned how nice the idea was, adding she would keep in touch after returning home. I added that it might be a rather extensive one, confined not just to my gallery but extending to similar galleries in the neighbourhood to which Maryrose responded enthusiastically.

A week later Maryrose and I had lunch with Mr. Robinson, the cultural attaché of the Australian Embassy and Mr. Dodds, director of The Australia-Japan Foundation, and who upon hearing about the idea paved a way for it to be formally realised. Commending the idea, they offered their assistance, suggesting an application to the Australia-Japan Foundation for a travel subsidy so as to enable appropriate research to be undertaken. They recommended the application to the head office in Sydney. Initially hesitant and with some reluctance, things gradually took shape and the plan started to materialise step by step.

The First Meetings in Japan and Australia 1981 – 1982

I penned and later submitted a handwritten outline, the rationale being to exhibit the most up-and-coming artists across a network of galleries in the Ginza, Shinbashi, and Kanda areas of Tokyo. The first meeting was held on 11 June, 1981 at Lunami Gallery, with representatives of just five galleries in attendance, along with Maryrose. I informed them about the details and the plan to showcase contemporary Australian art through solo exhibitions across participating galleries. The Australian government supported the realisation of the plan by providing a backing sum of ¥10,000,000. I would also visit Australia, with the support of the Australia-Japan Foundation, to select participating artists.

I asked the various gallery owners to collaborate in this unique cross-cultural plan, a first of its kind in Japan. Some thought the plan appeared to be under-financed, however I undertook to report on my visit to Australia and then provide more information about matters after my return to Tokyo.

After the first meeting, it appeared that at least 10 galleries were needed for the exhibition. I was ashamed not to see Japanese financial support and explained the plan to the Japan Foundation (JPF). Mr. Hayato Ogo, in acknowledging the limited financial support, asked for some patience, later verbally promising ¥1,000,000.

Before my departure to Australia I met Stelarc, the Australian performance artist then living in Japan, in order to gather more information about Australia. I also met with the Japanese artist Goji Hamada who had performed in Australia at the Japanese exhibition *YOIN* in Melbourne.

The *YOIN* Exhibition: Ideas from Japan, made in Australia, 1981

A number of Japanese artists including Goji Hamada and Tadashi Kawamata visited Australia on the occasion of *YOIN*, an exhibition consisting of the works of 27 Japanese artists executed with assistance from 70 students of various art schools in Victoria, according to plans and instructions sent by mail, and shown at the Gryphon Gallery, Melbourne College of Advanced Education, The Victorian College of the Arts

Gallery, and the lawn area adjoining the National Gallery of Victoria. It was organised by Stelarc and Ken Scarlett, the latter then director of the Gryphon Gallery. The exhibition, not so well publicised in Japan, is regarded highly in the Australian art world as a memorable step towards an ongoing cultural exchange between Australian and Japanese artists.

My first visit to Australia occurred from 28 April to 13 May, 1982.

- **Tuesday, 29 April, 16:00: Arrived Sydney**

Ann Flanagan, a friend of Maryrose, came to pick me up at the airport and wore a Kimono given by me to Maryrose. I didn't know at the time, but Ann would later work with me as the coordinator of an exhibition entitled *Tokyo Connection* in 1990. That night I discussed with Ann and Maryrose the most important points for the following day's meeting.

- **Friday, 30 April, 10:00 am: The 1st Meeting at The Visual Arts Board of the Australia Council**

In attendance were Ann Lewis (Chairman of the Visual Arts Board), Nick Waterlow, Tony Bond (Assistant Director, Art Gallery of Western Australia), Jim Allen (Director, Sydney College of the Arts), Maryrose Sinn and me. I elaborated upon the plan and the purpose for my two-week visit would include setting up an Australian Committee, defining the content and scope of the exhibition and selecting appropriate artists.

Thereafter I started visiting galleries, museums, artists' studios and art colleges. I saw the 4th Biennale of Sydney, 1982. I also presented a slide show of Japanese artists' works at the Visual Arts Board of the Australia Council, and at Prahran College of Advanced Education (Melbourne).

- **Wednesday, 5 May-Monday, 10 May**

I flew to Melbourne. I had to establish a committee in Australia to promote the exhibition between the two countries. Maryrose nominated the notable art critic Judy Annear who had curated many exhibitions of work by young artists in Australia.

I went to see Judy Annear, director of the Ewing & George Paton Galleries at the University of Melbourne. Being busy and preoccupied at the time with preparations for the first public art centre, Art Space, she did not work with me then. However, she introduced me to Ken Scarlett, director of the Gryphon Gallery at Melbourne State College as the most suitable person to team up with. Ken was Stelarc's teacher (the two having brought the exhibition *YOIN* to fruition), and willingly accepted my request with regards to setting up an Australian Committee.

I met John Davis, an artist and professor at the National College of the Arts and Akio Makigawa, a Japanese sculptor living in Melbourne. They greatly assisted and helped iron out all the various teething problems that come with such a venture. On 7 May I visiting Noelene Lucas at Prahran College. She showed me the wooden materials dumped outside for Tadashi Kawamata installation in *YOIN*. Then Maryrose, Judy, and I visited Ken on 9 May to discuss matters again, clarify the content and artist's selection I had prepared beforehand. The next day, 10 May, I returned to Sydney and was introduced to the video artist, Peter Callas, by Maryrose. Peter had received an award at the International Festival of Video Art, Kobe, Japan in 1981. He assisted me as a bridge between Japan and Australia. He had also received a grant from the combined Australian Film Commission and Visual Arts Board Grant to live and work in Japan.

The Exhibition's Concept and Selection

Given my need to select works and introduce something new to a Japanese audience, I pondered about the roots of Australian contemporary art. I thought that contemporary art in Australia could be classified as post-conceptual art. Based on the unique climate of Australian nature and Australia's particular artistic culture, I set up three main themes: Earth, the Environment and Multicultural Society.

Most of the artists I visited lived in cities on the Australian coastal fringe circumscribing the red land and were influenced by aboriginal art and history. At the beginning of the 1980s Aboriginal art appeared more as a craft, though it gained more recognition as a form of contemporary art some years later. My particular interest was informing Japanese

audiences about Australian social movements through solo shows and group exhibitions.

I selected works that involved a range of media including installation, photography, video, film, performance, sound, posters, artists' books, and documentation of the Women's Art Movement. Many of the creators were extending their interests into areas which were once tangential to the visual arts, such as psychology, anthropology, Marxism, feminism, documentary, popular art forms, and so on. We cannot understand Australian culture without understanding its influence upon history, its landscape, and also its urban life.

Continuum '83 was the title suggested by the Australian committee that was best deemed to encapsulate an artistic exchange between Australia and Japan into the future. The Japanese committee agreed, adding *The 1ˢᵗ Exhibition of Australian Contemporary Art in Japan* as a subtitle.

Continuum '83: Organisation in Australia and Japan

The Australian Committee was chaired Akio Makigawa and involved members in Melbourne, Sydney, Tasmania and Perth. The Melbourne committee members included Ken Scarlett, John Davis and Jennifer Phipps. The Sydney committee members included Judy Annear, Terence Maloon, John Williams and Peter Callas. Leigh Hobba was the committee member from Tasmania and Perth was represented by Tony Bond.

All the people on the committee were either artists, had full-time positions as lecturers, or were curators or gallery directors, so nobody welcomed time-consuming meetings. The main Melbourne committee only met to discuss major issues, matters of policy or urgent problems, though all members continually kept in touch by phone. All significant correspondence was sent to members so that people were kept informed. In order to make use of members' special interests and spread the workload, various parts of the exhibition were curated by separate individuals.

The Japanese organisation, Japan-Australia Art and Cultural Exchange Committee consisted of 15 gallery owner-directors and who would participate in the exhibition in Tokyo. Goji Hamada helped as a bridge between the Japan and Australian committees and took responsibility for

Studio 200. He organised the Contemporary Australian Art Lecture Series at INAX Gallery, Tokyo before *Continuum '83*.

Akio Makigawa who lived in Melbourne worked with us, allowing us to solve various issues and logistical problems that were pertinent in both countries.

Funding cooperation with public and private bodies

Continuum '83 was funded by public entities the Visual Arts Board in Australia, and by both the Japan Foundation and the Australia-Japan Foundation in Japan. However, we also looked for additional support form a number of commercial organisations in Japan, despite a shortage of support in the sector. In the early 1980s it was difficult to fund creative endeavours in Japan, as almost all companies had next to no awareness about supporting the arts support at the time.

We had to use private connections to raise funds and were finally successful in securing funds from 30 companies. We had to approach the heads of different organisations in different industries for support, including the steel and textile industries, who began to contribute money each year. We were lucky not to have landed in the red. We were delighted that the Australian Embassy came to our assistance by providing storage space, where the exhibition needed to be unpacked prior to delivery to each gallery. Japanese artists helped by setting up things at each gallery and by communicating with the Australian contingent.

The Opening of *Continuum '83*

Alison Broinowski, First Secretary (cultural) at the Australian Embassy, who was interested in the further development of cultural exchanges between Australia and Japan, greatly assisted the exhibition. There were 30 people who came to Japan from Australia for the event, including exhibiting artists, committee members, art students and broadcast and media individuals.

Sir Neil Currie, the then Australian Ambassador, generously held a reception at the Australian Embassy on the afternoon of the opening of *Continuum '83*. This was not only an opportunity for an official opening

speech, but also provided the chance for a stream of exchanges between artists, curators, gallery directors, art critics, photographers, journalists and so on.

Continuum '83: The first exhibition of Australian contemporary art in Japan:

Continueem '83 was held between 22 August and 3 September, 1983. It was promoted through the taglines, "What are the roots of Australian contemporary art?", "70 promising Australian artists come to Tokyo this summer", and "Art exchanges linked with 15 art spaces in Tokyo!". The exhibition included seven separate artistic mediums and a symposium.

Installation work included Keven Mortensen's exhibition at the Awajicho Gallery, directed by Kimio Hasegawa, Adrian Hall's work at Independent Gallery (supported by artists), Brian Blanchflower's work at Gallery Hinoki, directed by Kuniko Takagi, Mike Parr's work at Gallery Yo, directed by Yoshie Mochizuki, Rosalie Gascoigne's work at Gallery Yamaguchi, directed by Mitsuko Yamaguchi, Ken Unsworth's work at Kobayashi Gallery, directed by Hitomi Kobayashi, John Lethbridge's work at Gallery White Art, directed by Emiko Nakano and John Davis and Peter Cole's work at Lunami Gallery, directed by Emiko Namikawa.

Photography work included a documentation of women's performance art curated by Anne Marsh and Jane Kent at Gallery K, work by Bonita Ely, Douglas Hollely, Noelene Lucas and Virginia Coventry at G Art Gallery, directed by Shinichi Goto and John William's work at AI Gallery, directed by Mie Wakana.

Holography work included Paula Dawson's exhibition at Surugadai Gallery, directed by Mistuko Kushida and a collection of posters and artists' books was curated by Judy Annear and Jennifer Phipps at the Ginza Bijutsu Club, directed by Mastumoto. Scan Video Gallery, directed by Fujiko Nakaya, held an exhibition of seven artists' video works that was curated by Peter Callas.

Stelarc performed at Space Luft and Lydall Jones and Mike Parr performed at Studio 200, located on the 8th floor of the Seibu department store. Studio 200 also hosted an experimental film and sound exhibition curated by Jennifer Phipps and Leigh Hobba. A symposium titled "Australia

Contemporary Art" also took place at Studio 200 and the panelists were Ken Scarlett, Jennifer Phipps, Rod O'Brien, Yusuke Nakahara and Goji Hamada.

These programs were organised by the Japan-Australia Cultural and Art Exchange Committee and assisted by the Visual Arts Board of the Australia Council, the Australian Embassy Tokyo, the Australia-Japan Foundation, the Japan Foundation and sponsored by thirty various companies.

The catalogue was a very important source of information in both Japan and Australia. We published a 96-page catalogue, which presented the artists, their works and the whole *Continuum* project with the text in both Japanese and English.

Continuum '83 received a great deal of advance publicity in the media and several important articles appeared in Japanese newspapers including the *Asahi*, *Yomiuri*, *Mainichi* and *Sankei* newspapers. Articles also appeared in the English language newspapers *The Japan Times*, *The Japan Times Weekly*, and *The Daily Yomiuri*. The *Ohara School of Ikebana* published a special issue highlighting aspects of contemporary Australian art and *Continuum '83*. *Bijutsu Techo*, a long-established arts magazine, also featured writing on contemporary Australian art for the first time in its history. This was a sort of landmark for our media activities. The total number of publicity items came to 26 in Japan and two items in art magazines in Australia.

Particularly notable was Peter Callas having undertaken to publish a special issue on contemporary Japanese art entitled 'Let's Asia!' in the magazine *Art Network* (Spring, 1984). The articles provided an historical perspective on Japanese avant-garde art in the1960s, as well as analytical descriptions of the directions being pursued by Japanese artists in the 1980s. I helped with the compilation totaling 26 pages, including a review of *Continuum '83* by both Japanese and Australian critics which ran for seven pages.

After *Continuum '83*

With the completion of the exhibition by a grass-roots organisation, the small galleries in Ginza were filled with the dynamic energy of

contemporary Australian art. It was the liaison and co-operation between fifteen galleries and the Australian Committee that led to the success of *Continuum '83*, and much was learnt. From its small beginnings this exhibition of contemporary Australian art became a notable event within the context of international art exchanges in post-war Japan, and a source of inspiration that opened new paths for us.

I received the copy of a report on the exhibition from the Visual Arts Board's Ken Scarlett, which included personal comments by committee members. John Davis commented that an artist-in-residence studio should be established in Japan at the earliest possible date. The Board also recommended considering reciprocal arrangements when deciding on other grant giving areas – such as visiting artists, artists-in-residence, artists from overseas, and so on. Ken Scarlett was highly commended for the excellent job he managed to do given very limited resources. Akio Makigawa was praised for the exhausting and generous help given in Japan.

It was also recommended that *Continuum '83* should be evaluated by the VAB and a reciprocal exhibition in Australia considered, with visiting Japanese artists helped as much as possible in return for their generosity and assistance. An artist-in-residence studio for visiting Australian artists should be established in Japan as soon as possible.

We were fortunate in having friendships with artists, such as Goji Hamada, before the commencement of the show, and which formed part of a long-term exchange process between the countries, both at a group level and an individual level.

The show worked well because it was supported by a large number of galleries and artists – not just a museum curator. There was obviously a genuine interest on the part of each artist in the other's culture. This was possibly the first show of Australian art held separate to the biennales and had been well-received in its own right – not as art simply reflecting European or American styles, but art which is appreciated for its own particularities and attitudes.

At the farewell held for the 27 Australian visitors, Ken Scarlett said "Let's hold a contemporary Japanese art exhibition, *Continuum '85*, in Australia. See you in Australia!" There was an enthusiastic response at the prospect of another exciting exchange of art. So began the journey

from *Continuum '83* to *Continuum '85*. An artistic event came into being through the co-operation of many people. In December 1983, we received an official request from Australia, and by January 1984 had formed a committee for *Continuum '85* with a new set of participating galleries. In partial replacement for the five galleries that decided not to participate, two other galleries joined us.

Goji Hamada and Stelarc joined as observers. Thus, the committee began working to make *Continuum '85* a success. After initial weekly meetings, we drew up a list of 60 artists and gathered documentary material for the Australian committee, who would then select the exhibiting artists. The reference materials of those not selected were to be kept at the State Library of Victoria in Melbourne.

Contemporary Japanese Art in the 1980s

The 1980s were very important for Japanese contemporary art, particularly as to why young artists had no direct influence from art trends, such as new painting, originating in the USA and Europe. Mono-ha, a Japanese artistic movement embracing aspects of conceptual art, refers to a group of artists who were active from the late sixties to early seventies, and who utilised both natural and man-made materials in their work. Their aim was simply to bring things together, as far as possible in an unaltered state, allowing the juxtaposed materials to speak for themselves.

In this respect, the artists no longer 'created' (in the accepted sense) but rearranged things and material to form artworks, drawing attention to the interdependent relationships between these things and the space between and around them. The aim was to challenge pre-existing perceptions of such materials and have viewers relate to them on a new level.

By virtue of Mono-ha's influence a new generation of artists appeared, with cutting-edge works realised as installations. Some consciously employed a traditional Japanese sensibility where, for example, the usual delineations between interior and exterior space are jettisoned, with work appearing in the environment with a kind of amorphousness, pertinently spiritual and imbued with a sense of Japanese aesthetics, and often realised in wood and natural materials.

On the other hand, the number of young female artists appearing in the spotlight was notable. Their works were often installations and characteristically 'flat' in format; typically imbued with imagination such as that of the memory of childhood, natural dreams, adolescent freedoms, faux-naïf manifestations of innocence and the like, and founded upon strong artistic creatively and with dynamic compositional integrity.

The Australian committee selected works that best represented and understood this backdrop to Japanese contemporary art. The content of *Continuum '85* was wide ranging, and included flat-format and other installations, painting, graphics, video art, film, performance art and architecture. Such material represented the prevailing art styles of the 1980s and indicated the then contemporary art trends in Japan.

One of the special exhibits in *Continuum '85* was 'New Graphics of Tokyo', in which day-to-day public visual images, such as posters, printed matter, TV commercials and photographs were the means by which to present the various facts and dynamic energy of then modern Tokyo. Koichi Tanikawa organised the setting up of what was known as the Real Station Kiosks of Tokyo, highlighting a key situation and the actualities of an information-based society. Two performance artists Akio Suzuki and Lei Ujika were also in Australia, where performance art had already gained recognition as an established art form. Then, *Continuum '85: Aspects of Japanese Art Today* was held in Melbourne from September 10-27, 1985.

The two exhibitions, *Continuum '83* and *Continuum '85*, had built on the basic art exchanges between both countries and saw cooperation with and between artists, gallery directors, and others. We were thinking about the most important way to progress to the next step in art. The Australian Committee had made a request via the report of *Continuum '83* to the Visual Arts Board of the Australia Council, about an artist-in-residence studio in Tokyo. The report included the following:

Studio for Australian Artists in Tokyo

In view of the growing contacts between artists in Australia and Japan, it would be extremely valuable to have a studio and accommodation available in Tokyo.

Over a period of some years there has been a flow of Australian artists to Japan, people who have been anxious to learn something of Japanese music, architecture and ceramic art, as well as the broad field of contemporary art. The growing awareness of the proximity of Asia has already influenced public opinion, politics and trade and will obviously be an important factor in the development of Australian art. It is the unanimous opinion of the members of the Australian committee that the time is opportune to open a studio in Tokyo.

Akio Makigawa discussed the project with Goji Hamada, who suggested a possible studio and residence.

I agreed with this proposal as the means to continue our desire, coined 'Continuum', to further art and cultural exchanges between Japan and Australia.

My Memories of art projects in Japan

Caroline Turner

The 1980s were a major turning point in art connections between Australia and Japan. Australian art and artists have been enriched by the many Japanese cultural connections since then. What has been achieved is not limited to exchanges between the two countries but has also involved exchanges which have helped define new approaches to contemporary Asian and global art. I first went to Japan in 1982. I have subsequently worked on many art projects with Japanese colleagues over the intervening period of more than thirty-five years. I led a cultural delegation to Japan in the 1990s and have been an invited speaker at conferences in Japan. I am most grateful to many people – too many to mention by name. I especially want to thank Sachiko Tamai for all the significant help she gave me during her time at the Australian Embassy. As well, I note the hard work and friendship of Emiko Namikawa at Gallery Lunami who introduced so many Australians to Japanese art. The Japan Foundation has played a very important role in Japan-Australia cultural relations and I want to acknowledge Yasuko Furuichi who supported many projects and invited me to many ground-breaking conferences on contemporary Asian art organised by the Japan Foundation. I particularly thank Masayoshi Homma from the Saitama Museum of Modern Art, Toshio Hara from the Hara Museum and curators and scholars I have worked closely with over the years, including Fumio Nanjo, Eriko Osaka, Akira Tatehata and the staff of the Fukuoka Asian Art Museum, including Masahiro Ushiroshoji.

I first visited Japan as Deputy Director of the Queensland Art Gallery. Our Gallery has been fortunate to have had three major exhibitions of historical Japanese art masterpieces generously lent by the Idemitsu Museum Tokyo and Mr Shosuke Idemitsu, beginning in 1982 with an exhibition of treasures for the opening of our new building. The Queensland Art Gallery and the Saitama Museum of Modern Art undertook major exchange exhibitions of the works of contemporary Australian and Japanese artists in 1987 and 1989 which I negotiated in the 1980s with the Director of the Saitama Museum of Art, Masayoshi Homma.

The exhibition of Japanese art in Australia in 1989 with over 40 Japanese artists was the first major exhibition of Japanese contemporary art seen in Australia. It was curated by Hidekazu Izui and Michel Sourgnes. This exhibition also provided the inspiration and model for the Asia-Pacific Triennial of Contemporary Art (APT), a continuing series of exhibitions of contemporary art from countries throughout the Asia-Pacific region which began in 1993 at the Queensland Art Gallery. The model for the APT of co-curatorship between curators from different countries came from Saitama. That model was suggested by Mr. Homma during discussions he and I had in the early 1980s.

The first three APT exhibitions showed two hundred and twenty artists from the Asia-Pacific region and Japan. The success of the Saitama exhibitions played a key role in our decision to launch the Triennial. Japanese artists have always been very important in the APT which now has a history of nine exhibitions over the period from 1993 to 2018 with well over two million overall visitors. This is a large attendance for exhibitions of contemporary art in a city, Brisbane, with a population of just over two million people and in a country, Australia, with a population of just under twenty-five million people. The Gallery has acquired a major collection, especially of Japanese art works, many funded through a donation in memory of Australian philanthropist Ken Myer and his Japanese-born wife Yasuko.

The Queensland Art Gallery's 2014/15 exhibition *We can make another future: Japanese art after 1989* showed 100 works by nearly 50 contemporary Japanese artists purchased by the Gallery since 1989. These include Shigeo Toya's *Woods III* (first shown in APT 1993) an eerie forest of large wooden blocks carved with a chainsaw, Hiroshi Sugimoto's *Sea*

of Buddhas, photographs of the 1001 gilded sculptures of Kannon at the Sanjūsangen-dō temple in Kyoto (APT 1999) and Yayoi Kusama's *Narcissus Garden* (first shown in the Venice Biennale in 1966) and *Soul under the Moon* (APT 2002). I am very proud to have played a role in some of these acquisitions. The Gallery also has historical Japanese works, including ceramics from the six Old Kilns of Japan which was the concept of our then Chairman of Trustees, Richard Austin, a great friend of Japan who was awarded the Order of the Rising Sun with Neck Ribbons by the Emperor of Japan for his work bringing the two countries together.

Australia's first cultural contacts with Japan were through 19th century expositions in Sydney and Melbourne. Items of Japanese decorative arts were much admired by Australians. Art exchanges began in the 1950s when exhibitions of Japanese paintings and decorative arts came to Australia including, in 1958, the *Hiroshima Panels* by Iri and Toshi Maruki which depicted the terrible effects of the atomic bombs. Australians interested in the superb traditions of Japanese crafts started to go to Japan to study from the 1970s. David Williams, Director of the Crafts Board of the Australia Council, attended the World Crafts Council conference in Kyoto in Japan 1978 and the Board began in the 1980s to establish links. The Biennale of Sydney has shown Japanese artists since the 1970s. Universities and art colleges such as the Canberra School of Art (Australian National University) began art exchanges from the 1980s. The Australia-Japan Foundation, the Australia Council for the Arts and Asialink have also supported many exhibitions and residencies for artists.

Memorable art exhibitions include *Art of Japanese Package*, 1979; Jackie Menzies' exhibition at the Art Gallery of NSW *Modern Boy Modern Girl: Modernity in Japanese art 1910-1935*, 1998; the Queensland Art Gallery's *Yayoi Kusama 'Look Now, See Forever'*, 2011/12; the Museum of Contemporary Art (Sydney) exhibitions *Zones of Love: Contemporary Art from Japan* 1991 (curated by Judy Annear); *Yoko Ono War Is Over! (if you want it)*, 2013 and *Tatsuo Miyajima Connect with Everything*, 2016. One of the most exciting exhibitions Australia has sent to Japan was of Aboriginal art; *Utopia, the genius of Emily Kame Kngwarreye* curated by Margo Neale and Akira Tatehata, Director of the National Museum of Modern Art in Osaka. The exhibition achieved great success at the National Museum of Modern Art, Osaka and the National Art Center, Tokyo in 2008.

I will end with some works by younger artists. Mayu Kanamori, who was born in Japan but now lives in Australia, has created an immersive performance and exhibition telling the story of Japanese photographer *Yasukichi Murakami* who lived in Northern Australia in the first part of the twentieth century, a major centre of the Australian pearling industry in which Japanese have long been involved. While this is a story of past shared history, Japanese Australian artists Ken and Julia Yonetani have created works related very much to the present and our future on a shared planet. In an installation at the National Gallery of Australia they showed *Crystal Palace: The Great Exhibition of the Works of Industry of all Nuclear Nations* (2013) a series of chandeliers made from uranium glass representing nuclear-powered nations and created in response to the horrific Fukushima Daiichi nuclear accident in Japan following the tsunami disaster of 2011.

My Tokyo Connection

Stelarc

*H*aving a Greek heritage and being educated in Western Culture and Art History, I was very interested in living in an oriental country after completing my education at Caulfield Institute of Technology, RMIT and Melbourne University. I was especially intrigued by traditional Japanese culture. Noh, Bunraku, Calligraphy were part of a living tradition that also included Sumo Wrestling. Then there was Butoh and Robotics. I moved to Japan in 1970.

It was not long after that I discovered the Akihabara electronics area in nearby Kanda and I visited there regularly. It was not for a year or so that I stumbled upon the Maki Gallery and its Director Yamagishi-san. It was a relationship that defined my artistic career for the 18 years I lived in Japan. Most of my art activities were centred around the Maki and Tamura Galleries (and also the Tokiwa Gallery through Yamagishi's introduction to Kazuko Omura). Yamagishi also had the Komai Gallery in Kanda and the Lumiere Gallery in Yamagata for some time.

Even though I spoke little Japanese and Yamagishi and his wife spoke little English, they were exceptionally polite and considerate of this gaijin and we gradually became very good friends. Even though his galleries were rental galleries, he would allow me to have my performances on days between exhibitions. There were several times when a Japanese artist cancelled a show at short notice, and he would offer me the space without cost. For someone like myself who could not afford the expense of renting the gallery, it was much appreciated. It allowed me to do performances

that were of much longer duration. I met most of my artist friends at the Maki Gallery when I would visit Yamagishi and hang out there with him.

On one occasion, during a very hot and humid day when I visited the Tamura Gallery I was met by a smiling Yamagishi who produced a large bottle of cold *sake* from his office. We sat on the floor in the middle of the gallery cooling ourselves off, sipping *sake*. There was more smiling than speaking. On another occasion I mentioned my interest in Sumo wrestling. Yamagishi offered to take me to one of the Tokyo tournaments and was able to get me permission to go into the dressing rooms and meet some of the wrestlers.

Over the 18 years I was in Japan, I did performances that involved sensory deprivation and physically stressful actions, a series of body suspensions with hooks into the skin, the amplified body installations and the Third Hand events. When I did a one-week performance at the Komai Gallery that involved stitching my lips and eyelids shut with surgical needle and thread and tethering my body inside the gallery with hooks into the back and cables connected to eyebolts in the wall, Yamagishi decided to sleep in this office, being concerned with my safety. I couldn't see or speak, drink or eat and it was cold at night. He was concerned about my personal health and safety. There was another one-week performance at the Maki Gallery when I was lying beneath a suspended one-ton rock. Again, Yamagishi slept in his office. One day, early in the morning there was an earthquake that shook the building. Still beneath the rock I remember glancing towards the office and seeing Yamagishi-san running out, still pulling up his trousers, reassuring me that being under the rock was the safest place to be, even though now it was slowly swing from side to side. Some of the interesting body suspensions included my *Sitting/Swaying: Event for Rock Suspension* on 11 May, 1980 at the Tamura Gallery in which the body's weight was counterbalanced by a ring of rocks. Yamagishi did not even hesitate in allowing me to drill 18 holes and anchor eye-bolts into the concrete ceiling. No problems! The eye-bolts remained in the ceiling for many years after the performance. Generally, the suspensions averaged between 15-30 mins in duration. But the shortest suspension was also at the Tamura Gallery. *Event for Lateral Suspension* on the 12 March 1978, proved especially difficult. The body was vertically suspended not from the ceiling, but rather from the side-walls. This meant the skin was stretched and tensed out, up and with a twist. It only lasted a minute before I passed out.

Yamagishi always trusted the artist. I attempted my first body suspension in 1975 at the Experimental Art Foundation in Adelaide. Because the media discovered what I was going to do and because of the pressure of medical opinion, the police were in attendance. Thirty minutes before it was supposed to happen, the EAF decided to cancel its support for the performance and the installation was dismantled. It was quite a traumatic experience, especially since the media the next morning asserted that it was a publicity stunt that was not really going to happen. Being determined to do the suspension performance, I was fortunate that Yamagishi-san allowed me to use the Maki Gallery and never questioned what I was doing and why I was doing it. In retrospect it was both trustworthy and courageous of him to allow such a problematic event in his gallery. It was the first of 25 suspensions over a period of 13 years.

In the subsequent publication in 1984 *Obsolete Body/ Suspensions/ Stelarc* (JP Publications, Davis, CA) which documented the suspension performances up till that time, Yamagishi contributed an article for the book and his assistance was especially acknowledged, along with H. J. Koellreutter, the director of the German Cultural Centre in Tokyo who had also sponsored my early performances.

I first exhibited the *Third Hand* project as a cardboard mock-up in a group exhibition at the Maki Gallery. The initial performances with the *Third Hand* when it was completed in 1980 were subsequently at the Maki and Tamura Galleries. For example, *Handswriting* (writing the word evolution with three hands simultaneously) was done at the Maki Gallery on the 22 May, 1982. It was documented by Keisuke Oki, now an internationally recognized media artist. *Telechiric Transmission: Event for 4 Hands* was between my studio in Yokohama and the Komai Gallery in Kanda. I was able to remote control my Third Hand attached to a host body (Keisuki Oki). That was on the 29 January in 1984. Oki-san also assisted with a number of suspension performances and has become a very good friend over the years. *Event for Amplified Body, Laser Eyes and Third Hand* was also performed at the Maki Gallery. For that performance Takuro Osaka did the lighting installation and Kazutaka Tazaki did the sound design. It was an interactive performance in which brainwaves, muscle signals, heartbeat and blood flow actuated and modulated the neon

tube and spotlight installation. As well as the body being visually extended, the sound immersed the audience in the body of the artist.

Yamagishi was influential in establishing connections with Australian artists. This occurred after an exhibition we planned for a group of Japanese artists in Melbourne with Ken Scarlett. As there was only a small budget the idea was to select works that could be planned in Japan but made in Australia. The title of the exhibition was *YOIN (Reverberations): Ideas from Japan, Made in Australia*. The artists were selected by myself, Vlasta Cihakova and Nobuo Yamagishi. They included Koji Enokura, Kintaro Fukuhara, Noriyuki Haraguchi, Toshifumi Hasegawa, Tooru Ikeda, Setsuko Ishii, Hiroshi Kamo, Ryosuke Kanuma, Tadashi Kawamata, Toshiharu Hisano, Mitsunori Kurashige, Kazusumi Maeda, Masayuki Muramatsu, Masaki Nakayama, Keisuke Oki, Hideo Osaka, Tomoaki Sakurai, Suga Kishio, Osamu Takagi, Noboru Takayama, U Tan, Mutsuo Tanaka, Kenji Togami, Morihiro Wada, Mie Wakana and Masafumi Yagi. This was done with the assistance of Ken Scarlett (at that time the director of the Gryphon Gallery in Melbourne) and the Victorian College of the Arts. Goji Hamada was also selected and he came to Melbourne and did a performance that involved suspending and gutting a shark which was expressive of his "Soft Language" concept. In subsequent years, Anthony Figallo did an installation at the Tamura Gallery and the sculptor John Davis had several exhibitions at the Maki Gallery.

Out of necessity this article is somewhat anecdotal rather than academic, rigorously researched or well-documented. It was done with a desire to acknowledge the friendship and artistic importance of Yamagishi's curatorial and gallery activities. He was passionate about art and was always open to creative possibilities. He became a highly influential and respected gallery director who also pioneered connections and exchange exhibitions with Australia and Korea. My only regret was not to see him in the final years of his life. He was a person who was complicit in most of my activities during the 18 years I was in Japan. I would visit Yamagishi's galleries at least once a week. It was where I met Japanese artists and became familiar with the Japanese art scene. Yamagishi-san sometimes appears in photographs of my performances and he will likewise remain a persistent and important memory for me and the many other artists who exhibited with him...

Acknowledgements

My performances in Japan would not have been possible without the assistance and collaboration of these friends and fellow artists: Takao Saiki, Keisuke Oki, Goji Hamada, Yasutaka Yuki, Yuichi Konno, Seiichi Ishida and Shigeo Anzai who photographed many of them. Takuro Osaka and Kazutaka Tazaki often did the lighting and sound for my *Amplified Body* and *Third Hand* performances. Other people in the arts who I knew and respected at the time were Emiko Namikawa and the freelance curator Vlasta Cihakova. Another friend who assisted and supported my activities was Takatoshi Shinoda, who was then working at Bijutsu Techo. Allison Bronoiwski who was the Cultural Attaché at the Australian Embassy in Tokyo was responsible for my performance using the 40 m X 25 m Sony Screen at the Tsukuba Expo, a screen that could be seen a kilometre away in daylight.

First written June, 2009

VACB Tokyo Studio

Sachiko Tamai

The VACB (Visual Arts and Craft Board) Tokyo Studio was established in 1987 when I was the Senior Cultural Officer at the Australian Embassy in Tokyo. I was involved in the opening, but I did not know any of the background to the project. Later, I learnt it was through the strong initiative of the Australia Council which decided to set up the program in Tokyo. Peter Callas was the key person, according to some artists including Stelarc. I asked Peter by email if he could tell me how the Tokyo Studio was first established. Here is an extract of his reply in November 2016;

> Hi Sachiko
>
> Thanks for your email, and for your efforts in collecting this history. [...] The essential points as I remember them are that Ross Wolfe, then Director of the VACB (or perhaps it was still the VAB-Visual Arts Board-at that time?) asked me to look around for spaces which might be suitable as an artist's studio for the Australia Council whilst I was in Tokyo. I first spoke to Prof. Gregory Clark who had, or knew of, a potential space in Chiba. I then discovered the Australian journalist Rodney O'Brien had been living in a prefabricated shed atop a building in Shitamachi and was planning to move out. I went to assess it and passed on the information to Ross Wolfe and left the negotiations to him. It was a foot in the door, so to

speak, until a more permanent solution could be found.
It lasted some time, though I'm not sure how long [...].

And it was for me, the Senior Cultural Officer of the Embassy, to follow up this story. It was to Monzennakacho (the actual address was Hiranocho) that Peter referred. I went to meet Naotoshi Sato, on behalf of the Australia Council, the owner of the building where Rod O'Brien used to live. Rod seemed to keep some distance from the Embassy, but I was lucky to talk with him on the phone a few times. He left the address very quickly and when I went to check the Studio condition before the artist arrived, a pair of new slippers were waiting for me at the entrance. That was a gesture by Rod expressing Japanese custom. It was one point I had to repeat throughout my involvement with the Tokyo Studio: that shoes should be off inside the studio until the end, in particular, in the studio in Takadanobaba which was a completely Japanese style apartment with two tatami rooms.

In 1986 Naotoshi Sato agreed to rent a small prefabricated house on the rooftop of a building in Monzennakacho, Tokyo to the Australia Council, Sydney. The contract was signed and sealed. The agreed amount of the cost including rent was paid from the Australia Council bank account in Tokyo that I opened specifically for the program. Because the Australia Council was not a legally registered cooperation in Japan, it needed a resident in Japan to open the account on behalf of it. Unused furniture-including a bed and a dining table with some chairs-from the Embassy's storage was carried in and some cooking appliances were bought by the Embassy staff on behalf of the Australia Council.

In January 1987 Liz Coats from Sydney commenced living in the studio under the Australia Council's program. Since then every three months (every four months at one stage), selected artists came in and left. It was completely managed by the VACB. Those artists who received the grant directly in Australia were instructed by the VACB on how to come and how to spend their days in Japan. The Embassy in Tokyo supported the program culturally and physically in the area of its cultural activities. I consulted the artists and gave advice when required.

The idea of an Artist-in-Residence was very new in Japan at that time. Even Tokyo was not very internationalized in the late 80s. Life in Tokyo

was so fresh and different for most Australian artists who took up the residency.

In 1990, the *Tokyo Connection* exhibition was held at the Heineken Village from 1 to 17 June and the 13 artists who had lived in the Tokyo Studio participated. Noel Frankham, then Director of VACB, was pleased to organise the show, since it was a good opportunity to show a part of the fruitful results of the program. In the exhibition catalogue, he wrote "Their commitment to returning to Japan and to organising a joint exhibition demonstrates the real need for artists to exchange ideas and to continually question the perceptions which inform of their work." Emiko Namikawa worked as the Director of the International Contemporary Art Exchange Committee set up for this exhibition in Tokyo.

Symposiums titled "Funding for the Arts, Australia and Japan" and "Artists Forum: The Studio Program" were held on 8 and 9 June in relation to the exhibition. Such events and media made an impact on the Japanese art industry and its younger generation of practitioners.

In 1995, the studio in Monzennakacho was not in good condition and Mr. Sato's son seemed not to be interested in his father's rather private activities. It was a time to try to find another accommodation for the Studio. I was lucky to be introduced to a person who was involved in the conservation activities of the Hosokawa family's old mansion and who knew Maekawa Industries through their business relations. They suggested I contact the company as they would be very positive about be being involved in an international exchange of such significance. After some discussions and research, the Australia Council agreed to sign the lease agreement with Maekawa Industries and a new studio was set up in a 2DK unit in Totsuka Heights in Takadanobaba. To rent a room for an overseas institute was not so easy around that time due to so many unspoken regulations for non-Japanese people and organisations, and the Australia Council in particular as a non-registered corporation. The Australian artists selected by the Australia Council were the only overseas residents in that old and huge apartment block in Totsuka Heights, operated by Maekawa Industries. The contract was concluded between the Australia Council and Maekawa Industries on 1 October, 1995 and since then the lease contract continued, signed by both parties every two years until August 2016. The rent was comparatively reasonable and the office staff

were so nice and kind, which is an important factor for the overseas visitors who were staying for three months in a country where the language and way of business are different.

In 1997, 10 years after the program began, a seminar focusing on the Artist-in-Residence program was held in Tokyo where Anna Waldmann, then Director of the VACB, was invited to talk about the purpose of the program and how it was received in Australia. In January 2000, I retired from the Embassy and a new officer for Public Diplomacy succeeded me and offered similar assistance for the program and resident artists.

In 2004 Anna contacted me to ask if someone could assist the program in Tokyo, since the Embassy said no staff could continue with the work due to changes in the Embassy's portfolios. I insisted the Embassy would be able to do a sort of minimum work since I believed that the Australian government's overseas mission should assist and support Australian artists, in particular those selected by the Australia Council, a governmental institution. However, after a brief meeting with the Administrator and Counsellor of the Embassy, I understood the change of situation and agreed to be a consultant and manager on condition that one more person would be brought in, since the studio was in a sense the property of the Australia Council and its operation money should not be handled by one person. I invited Emiko Namikawa to work on the program. Emiko had a good knowledge of contemporary Australian visual arts from the early eighties onwards and was the actual organiser of many of the above-mentioned projects, having worked with me while I was Senior Cultural Officer at the Embassy.

The space was called a studio, but it was actually Japanese style accommodation where there was not much practical space for any creative work, but the artists appreciated having such a place in Tokyo as a base to continue their practice and exchange with the Japanese art sector. The Tokyo Studio had a nice tradition in which the artist left a letter for the next artist with information about life in Tokyo, even if they did not know who the next resident would be. I called them love letters and they told of good coffee shops or late-night eating places around Takadanobaba and included news about the art sector in Japan as well. The letters illustrated Japanese society through the experience of Australian artists.

This Artist-In-Residence program, now called AIR in Japan, was developed and popularised in various ways and there are now more than ten public and semi-public programs, in addition to various privately-run programs, in Japan. The Tokyo Studio was the start of a trend in Japan's art sector and it has been described by Yasuko Ogiwara from Kigyo Mecenat Kyogita as "the first genuine AIR program" in Japan.

In September 2015, the CEO of the Australia Council called Emiko and me to announce the closure of the Tokyo Studio in August 2016. Nothing continues forever in this world and it was understandable that time had come for the Tokyo Studio to finish. Emiko and I, as managers, insisted that the CEO to close it with dignity after such a long history, but no official announcement was made by the governmental body and no archive of its history was made. Still the program was highly regarded and we were happy to have so many private reunions as it closed.

Zen and the Ryoanji Garden

Noelene Lucas

*B*y the time I actually saw the garden in 1983, I had been seeing it in my mind for years. The first image of it I ever saw was a poor quality black and white one and I probably would not have noticed had there not been a diagram beside it. I thought this diagram was trying to explain the connection, on another plane, between the disparate elements of the garden. I was fascinated. I even made a sculpture that speculated on my misinterpretation. Seeing the great art works of the world through poor quality reproductions was how I mostly learnt about art, as I did not go overseas to Europe until after art school. So, for almost every iconic artwork I saw, there was an imaginative leap for me to try to understand how it would be in reality-its weightiness, scale or detail. This is the condition of art on the periphery, where one is neither in Asia nor in Europe. What intrigued me the first time I saw that image of the Ryoanji garden was that it was designed for contemplation. That was its function; it was not for walking in, not to provide floral decorations for the house, nor was it there to increase the market value of the property. It was there for contemplation. For me this was significant as that was how I thought about sculpture and installation.

The first time I saw the garden in 1983, it was a steamy August Kyoto day. I had walked quite a distance from the baroque Golden Temple. I was hot, tired and wet and looking forward to the tranquility of the garden. Even after I left the street and entered the temple grounds there was still a long walk up a hill past a pond, a ziz-zag bridge and some buildings. At the entrance to the building I took off my shoes, paid the entrance fee,

walked past the *omiyage* shop, looked out over the beautiful garden and then picked my way between the crowd of Japanese tourists sitting on the veranda or its steps. It was very quiet, the tone respectful. People spoke, if at all, in hushed tones, to the background sound of clicking cameras. Many people came and went, sat for short periods and left because the garden does not easily reveal itself and the tour groups had to be at a certain hotel at a certain time for lunch. But that's how we see in the age of mass tourism. The circumstances of my first viewing of the garden were not ideal.

I sat there alone thinking *OK now I'm here, what next?* It's gorgeous. The dynamics of the composition work quite differently to what I had imagined from Melbourne. The garden was much wider and appeared flatter, the rock groups spread and appeared to cling to the gravel because of their triangular shape. They alternatively seemed to be rooted in place and sliding across the surface. I went to see it with the awareness that I should be open and receptive, that I should leave behind preconceptions, leave behind my mental chatter, including my need to analyze. But it was through analyzing that I started to understand the garden the only way I could. I could have done an inventory, yes, a long narrow ground covered in raked gravel with five groups of rocks, three towards the right end and two more to the left. I could have done an aesthetic analysis and gone. I could have taken in and been happy with what the tour guides stated the garden meant, but I was astounded that this garden embodied a philosophic doctrine, of which I knew very little. So, I sat and thought about what this could mean beyond islands in the ocean of existence, mountain tops above the clouds that obscure the nature of existence. Were these just tourist literature clichés? Was the meaning there, but made banal and stripped of real meaning? What more was it about?

I had been trained to read images and to be sensitive to the levels of perception that constitute the apprehension of a sculpture. Like the awareness of the body in sitting practice, the rhythm of my breathing, the beating of my heart, these too are incorporated into my perception of sculpture. I later realised that strangely enough this is where the perception of sculpture, meditation practice and the appreciation of the garden coincide. But back in 1983 it was by analysis and relating the garden to an expanded idea of the perception of sculpture that I started to get glimpses

of the complexity and meaning of the garden. Whether I was there or not it became the place for me to think through and expand my ideas about contemporary art; about space as a fundamental aspect of my art practice-space and positioned relationships and how the invisible connections of things in space could be worked.

I realised then that I was not going to understand the garden just by being there. That if I was to more fully appreciate it, I needed to become informed. Even when I had read a lot about the garden and Buddhism and had practiced meditation, there was still a loss through cultural translation. But Zen relies on experiential transmission, so I understood that it would be through practice that I would come to some understanding of the garden.

I have now seen the garden in a number of seasons and at different times of the day. Rich colours at sunset on a cloudy day, wet and glistening in a steamy mid-summer day, stark and bleak in winter and almost baroque in spring with the cherry blossoms in bloom behind the long wall. Because, of course, this garden is unlike the modernist art in the white cube, contaminated by its surroundings and they are acknowledged as part of it, as 'borrowed landscape'. These transient qualities evoke thoughts of the fleeting nature of being. A garden of rocks seems a strange thing for meditation on impermanence.

However, as it is a Zen garden I think it needs to be addressed in relation to the nature of reality in terms of Dogen's "being time" and being present to the moment. According to Dogen the aim is to see life as it is, and so perhaps the garden is simply fifteen rocks on a flat bed of gravel. Dogen is well known for saying that absolute reality is before your eyes. If one sits in *zazen* and just sees the flow of thoughts and events one sees the nature of existence as impermanence. Everything is change including us. Dogen equates life with time; that is, he teaches that we live as time, what he called being-time *(uji)*. Being-time has two aspects: firstly, it is right now this moment. A Zen practice is to be immersed in the present, without memories and worries of the past or future, total involvement in "now". Secondly, for Dogen, time is also passage, "now" is not an isolated "now'" but the point between past and future events that continues without gaps. Within this concept of flow, impermanence is implicit. This being-time is central to my understanding of the perception of installation: being present to the moment, to what is happening now.

Global Exchange

Anna Waldmann

After 13 years as director of the Visual Arts Board (VAB) of the Australia Council, I believe more than ever that the sense of dislocation, of personal and cultural shifts, that defines the 21st century can be negotiated through art and artists who have the ability to redefine our parameters by shifting the conventions of national and cultural traditions.

We often speak about "soft globalization" – it's what I attempted to do over more than a decade: to place Australian art in a broad international framework through specific strategies, projects and overseas studios. I made sure that our artists were visible in Shanghai, Kassel, Venice, Sao Paolo, Berlin, Istanbul, Liverpool, Gwangju and Yokohama.

Trying to cross the gap of knowledge and experiences through conferences, exhibitions, residencies and exchanges, we matched our identities with the rest of the world. We made cultural dialogue a reality. An important part of this dialogue were VAB's international studios, much loved by thousands of applicants.

I think studio residencies are an integral part of what artists do, they affect the multiplicity of contemporary visual culture, they are essential to our artistic practices, to our aesthetic concerns and to our innovative investigations. Residencies are testing the limits of artists' perception and encourage them to take a deep breath so that they can become part of the stillness, dislocation, gravitas and sheer aesthetic joy that surround good art.

Because art has become a global exchange, there often is a certain kind of generic, contemporary art idiom in operation: the rise and rise of

biennales, paralleled by the increase in the number and power of art fairs and private museums, cultural relativism and market imperatives, events bewildered by their own cultural and artistic identity, artists and curators becoming cultural entrepreneurs and talent scouts, and transmitters of a zeitgeist.

I know however that Australian artists are good at questioning, lateral thinking, intellectual risk, creativity and experimentation. Their practice is robust and situates itself strongly within a growing horizon where nationality has in many ways become redundant. The engine room of our culture lies in individuals, places and institutions that work with our artists and the public to make sure that all is not lost and forgotten. I think 'home' is as much geography as ideal and I often wonder if in fact we are all in the periphery, trying to cross the gap of knowledge and experiences.

Australia has had a love affair with the cultures of Asia for many decades. The Tokyo 'experiment' was always special, led by active local supporters and by an Embassy that valued the idea that it's good to engage with another culture. I went to Tokyo to participate in cultural forums organised by DFAT, to visit the VAB Tokyo Studio and to meet Japanese curators many times. We went on tours of museums across Japan, we spent time talking to the local authorities, we visited commercial galleries, travelled by bullet train, looked at dozens of institutions and it was an enlightening experience. We invited curators and directors of art galleries and contemporary art spaces back to Australia, we encouraged touring exhibitions. This is how long-term relationships are shaped and informed – not by received images and ideas symptomatic of a distance from the 'centre'.

For a long time, Australia seemed bewildered by its own cultural and artistic identity. But the very conditions of culture in Australia are now able to be articulated with confidence on a large international platform and in particular on the Japanese stage. In Alex Miller's novel *Autumn Laing* (Allen & Unwin 2012), one of the characters says "All art needs its champions. Without champions, art remains in the racks of the artists' studios and is unknown to us and uncelebrated in the world". We need new champions that understand how important the exposure to different worlds is, how essential a few months of immersion in another culture is in opening artists' souls and minds.

Part II

Reflections on Living in Tokyo by Artists-in-Residence

Dr Elizabeth Coats

Methods: Painting

Residency: 1987, Monzennakacho

Most vivid memory:

Experiencing the connectedness of Japanese social and cultural life as I walked in the streets, visited galleries and visited historic buildings.

What are you doing now?

I am now, and have been for many years, working full-time as an abstract painter. Currently, Visiting Fellow at the School of Art, Australian National University, where I completed a doctorate in painting research (PhD.) in 2012.

What are your future plans?

A curated survey of my work with abstract painting from the past forty plus years, with a published catalogue, opens at the Drill Hall Gallery, Canberra, in October 2017. In February 2017, my work will be included in a curated survey exhibition outlining the history of modernist Australian women's abstract art, for touring by the National Gallery of Australia to regional galleries in Australia. The commercial gallery, Utopia Art Sydney, exhibits my paintings with solo and group shows on a regular basis. I have a continuing relationship with the Environment Studio at the Australian National University, Canberra. Most recently, in October 2016, I presented a paper and exhibited in a group exhibition for a conference titled "Art &

Futures: Energy, Climate, Culture", at the Dunedin School of Art, New Zealand, with a publication pending.

Reflections:

Extract from Liz Coats, 'Artist Diary', in Australian and International Art Monthly, Issue No.7, December 1987.

After spending a short four-and-a-half months in Japan, I don't want to sound authoritative about what's going on there. I do not speak Japanese. But the experience was an adventure that, to some extent, one can only surrender to circumstance.

I was constantly stimulated in the local environment, feeling a strong sense of unspoken communication with people. The triggers were often visual, evoking thoughts that drew me back to my own cultural position.

I went to Japan at the end of December 1986, as the inaugural artist-in-residence at the Tokyo Studio of the Visual Arts Board, Australia Council. I experienced a degree of independence, while accepting responsibility as a representative of the VAB in Japan. People insisted on introducing me in this capacity. Indeed, I found a certain security in these introductions, enjoying friendly if mainly gestural conversations, and ease of entry around a portion of the Tokyo art scene.

Ideally one is balanced in a kind of continuous present with immersion in a new country and cultural context. I was told on several occasions that Japanese people are generally not good at verbally expressing abstract concepts. Whether or not that is so in conversational language, I noticed anywhere I went, invigorating abstract concepts expressed through everyday objects. I was constantly attracted to these signs, juxtapositions and rearrangements that drew attention to fabric and meaning. Perhaps this indicates a natural belief on the part of Japanese people, to the spirit or energy in all things.

For instance-cherry blossom time. Cherry trees are grey and spindly in winter; you would hardly notice them. But the blossom simply explodes on bare twigs on a certain day in early spring. Faintly pink petals, luminous in semi-darkness, envelope the trees with an overblown haze.

Some understanding of the intensity of the ritual became clear a few days after my venture into Ueno Park, when the petals began to fall. On the path we shared, I noticed a mother stop with her daughter, perhaps four years old, and point up at the drifting petals. I saw snowflakes. Need it be said. We are still attached to this earth, amongst all the concrete and traffic, and the season has turned at last.

In many ways, the contemporary art scene is still very much a subculture, surrounded by imitations of the art of late 19th-century France, or the indigenous Sumi-e and Nihonga painting. There seems to me, however, among younger artists, an acute awareness of self-consciousness. So they are creating juxtapositions, ephemeral environments and fragments of works with a variety of optional resolutions. Current work that I saw, presents a mixture of traditional and outrageous elements, signaling a commitment to change; the overcoming of cultural restraints and resistance by a largely unsupportive society.

Most artists I met with were doing jobs like teaching or producing artwork for advertising on an occasional basis and living with parents. Some of the older male artists were supported by their wives. In the younger group, women artists are forming loosely supportive groups, and gallery owners are frequently women. There is no doubt that the breadth and range of experimentation going on now goes hand in hand with the numbers of women entering the art scene. There is so much fresh art being made in Tokyo. Most of it is also quite ephemeral, intended to last the week of the show, then carefully photographed and dismantled.

In spite of the explosive and deconstructive nature of much of the interesting contemporary artwork, I found the cultural environment really supportive of my instinct for exploration and testing of interactions amongst materials. I experimented with a variety of Japanese handmade papers that show barely detectable differences until worked with, when water absorbency and slight textural differences affect the spread of paint. I discovered Japanese colour pigments, similar to those in other parts of the world in many cases, but some of the reds and blues I found to be unique, exhibiting subtle refraction and transparency not previously experienced.

By the end of the Residency, I was happy to take back to Sydney, a group of works on paper that advanced my long-term exploration of interactive colour images, later exhibited with larger canvases.

Dr. Noelene Lucas

Methods: Installation, sculpture and video.

Residency: 1987, Monzennakacho and 1995, Monzennakacho.

Most vivid memory:

Regular visits to Lunami Gallery. Return visit to Kyoto to see the Ryoanji Garden. Writing and practicing a conversation in Japanese that I could use to get second hand wood for a sculpture to be shown at Lunami Gallery.

What are you doing now?

I am now a full-time artist after 24 years lecturing at the University of Western Sydney.

What are your future plans?

More now work, more new projects & more exhibitions.

Reflections:

Seeing Double

When I arrived at the Tokyo studio in Jan 1995 it was like coming home. I was fortunate enough to be a resident in the Australia Council Tokyo Studio twice, the first time in 1987. During residencies the unforeseen can happen. This second residency was memorable not only because it gave me the opportunity to be immersed and to go more deeply into

aspects of Japanese culture, but also because it gave me an unforeseen set of experiences courtesy of the forces of nature.

"…..reality itself is two-layered."

There is a type of meditation in Buddhism called "death's head contemplation". It is a common theme in Japanese art and is often depicted as a skull lying in pampas grass. The haiku poet Basho, who wandered Japan in the seventeenth century, once spent a night in a field.

"Lightning flashes –
Close by my face,
The pampas grass!"

"A living man experiences himself, in the image of a skull on the pampas grass." A flash like that can reveal the world as a pampas field of death.

Two days after I moved into the Tokyo Studio for my second residency, in January, 1995, the Great Hanshin Daishinsai struck Kobe. At 5.46 am on January 17, 1995, a 20 second earthquake which measured 7.2 on the Richter scale hit Japan's sixth largest city, Kobe. It collapsed houses, destroyed roads, rail lines and ports. It ignited fires and left 5,470 people dead. 33,000 people were injured and 300,000 were made homeless. This was the worst earthquake to hit Japan since the Great Kanto Daishinsai (Tokyo earthquake) of 1923. The epicentre of the earthquake was less than 20 km under Awaji Island just off the coast from Kobe.

The central part of Kobe, which was composed of traditional wooden houses and the port area, was built on reclaimed ground. Here the ground liquefied and acted like a thick soup. Liquefaction happens to land around bays, lakes and rivers when the movement of a quake causes the soil particles to separate and move in suspension in the water. Everything in central Kobe collapsed and then burnt. The fires that consumed the centre of the city lasted for days, roads were impassable, there was no water and no electricity.

Everyday, long lists of the names of the dead scrolled down our TV screens and all day, everyday there was nothing but images of the disaster.

I was so shocked, I was compelled to watch, I couldn't stop watching it was so terrible.

The world as a field of pampas grass.

Kobe is situated on a narrow flat band of land between the sea and the mountains that carries all the communication infrastructure between north eastern and western Japan. All roads and rail lines were cut, western Japan was isolated from the rest of the country. The theoretically indestructible Shinkansen (Bullet train) track collapsed in eight places, the cities elevated freeways were also supposedly indestructible but they too collapsed, fifteen concrete pillars broke at their bases, huge sections of the road tilted at 45 degrees, other parts just fell to the ground. The roads everywhere were broken and either covered or lined with collapsed houses and multi story buildings.

Three weeks after the Great Hanshin Daishinsai, I left Tokyo headed for Shikoku Island, to walk a section of the Kobo Daishi 88 temple pilgrimage that circles the island. I had no idea that the route west was still through the very centre of Kobe. I will never forget the train ride into Kobe. Osaka station was crowded and chaotic, rail staff were placed at likely locations advising people on the routes they now needed to take to their destinations. I received my instructions and wrote them down. I should have been more alert, I should have reacted to the name Nishinomiya. Leaving Osaka (Umeda station), many people were talking as if it was just any other day. But as the train gradually moved into the area of total destruction, everyone was silent. No one talked. I was shocked I hadn't expected to be here to see this. Many people had tears in their eyes, we could see the damage everywhere. The centre of the city was flattened, just piles of black rubble. I was completely overwhelmed by what I saw. Elsewhere enormous buildings had toppled over like playing cards.

The world revealed as a field of pampas grass.

The Hanshin Railway could not take us all the way as the rail lines were still damaged. Near the centre of Kobe we got off the train and walked in a very slow moving line for several hundred metres through the

decimated city and then we were guided to buses which took us to where we could resume our train journey. But this was only after another long slow walk along damaged and devastated streets. I saw office blocks and apartment buildings that were several stories lower than they had been, they looked quite normal until I realized that the bottom three floors were now half the height of one floor. Just squashed. One building had a car half in and half out of the garage, the rear looked perfect, untouched. A Curtain flapped in the breeze in glassless window, to revealed an image of Kannon, the Bodhisattva of mercy. The wall it hung on now at a 60 degree angle. Hand written signs were posted everywhere letting families know that members were alive. Other signs begged for help to find loved ones.

Japan had invested huge amounts of money into earthquake research and the nation was shocked, this earthquake rocked people's confidence in science, engineering and in the emergency response. And nowhere so more than in Tokyo, a huge feeling of insecurity swept the city. Most of us lived and worked in high-rise buildings that were 'designed' to withstand large earthquakes just like the buildings in Kobe. The Tokyo Metropolitan Government building, designed by renowned architect Kenzo Tange and completed in 1991, has 48 floors, the thirty eighth floor was where I taught English to staff of the Expropriation Department. The views were wonderful. But after the Great Hanshin Daishinsai, I never went into that building without thinking how it would react in the next Great Kanto Daishinsai. Would it bend like bamboo? During the regularly occurring small earthquakes tables and chairs would slide a little across the floor, but next time would we all be flung from one side of the building to the other? Or would the building snap in two like the pillars of the elevated freeway in Kobe. I would tell myself not to let my imagination run away with me, and I have to say one just gets used to it and tries to accept life as impermanent.

But this was not helped by constant commentary and images on TV of what it would be like when, not if, a similar earthquake hit Tokyo. The local council organized a disaster plan, sent out information brochures on what we were to do during and after the earthquake. Earthquake drills were organized, we were told what we were to have in the earthquake kit (a rope ladder, torch and transister radio – make sure there are fresh batteries) and the new regular daily routines we all must now engage in to reduce the

hazards, especially of fire. The studio was in Monzennakacho and the land was reclaimed land and it still had picturesque canals running through it. I was fully aware that the earth under my feet would liquefy and the 1970s building on which the studio rested would crumble. If I survived would I be able to find my way to Australian Embassy in the rubble? Would I be able to cross the river to get there as the bridges over the Sumida River would surely collapse? I could not see the city just as it was, it was always "two-layered". I couldn't see the map, the town, the buildings, and streets without seeing the impermanence of it all, and of all our lives.

It was a flash that revealed the world as a pampas field of death.

As a response I made a work called "Seeing Double" in which I reproduced a road map of Tokyo with Sumei ink and brush in shaky nervous lines. Over this I placed the details of a map which one of my students at the Tokyo Metropolitan Government acquired for me. The information it contained was not secret but was not in common circulation. This map dated and marked the location and magnitudes of every earthquake that had occurred in the Kanto region in the last century. I marked this information on my drawing in red. It was a blaze with red.

"This kind of double exposure is the true vision of reality. Reality requires it." Life and death appeared to me to be equally real at that time. The whole of Tokyo seemed like the pampas field of death. I lived them both together, Nishitani says it more clearly when he states "It is *both* life and death, and at the same time it is *neither* life nor death. It is what we have to call the nonduality of life and death." The earth bubbles and shakes in Japan, it feels new and in the process of becoming. Nature and natural phenomena are indifferent to my life and death and to yours. For a life lived in the midst of this becoming, it is hard to see the world other than impermanent and transient. There is a beauty in this. Several months after the great Hanshin Daishinsai the cherry blossoms flowered in Tokyo They were spectacular for a week, and were gone.

Geoff Kleem

Methods: Photography and installation.

Residency: 1988, Monzennakacho

Most vivid memory:

Tokyo's scale and complexity, a city of delightful contradictions.

What are you doing now?

Exactly now, I am Resident Artist at Cité Internationale des Arts, Paris. Generally, I am a practicing artist and lecturer in Sydney.

What are your future plans?

I will continue to make work.

Reflections:

My residency was two decades ago though I have returned to do some exhibitions since then. I remember the cultural disconnect I experienced as wonderful and liberating. Having to negotiate a very complex and different cultural experience, attempting to learn how it all worked and then for a short time live within it was incredibly stimulating and beguiling.

After I returned to Australia, I became very interested in advertising processes and determined to make a body of work via utilising this approach most probably the outcome of my exposure to the overwhelming visual impact of what I was seeing everywhere in Tokyo.

Janet Laurence

Methods: Installation and mixed media.

Residency: 1988, Monzennakacho

Most vivid memory:

Exploring the neighborhood, the old streets, the architecture, the timber workers, the tea shops and Shinto temples. My time talking with the landlord, the late Mr. Naotoshi Sato, who was a wonderful character and whose remarkable funeral I attended.

What are you doing now?

I just completed Environmental Art artworks in Berlin, Belgrade, Cuenca Ecuador, and Paris and a large installation in Sydney at the Australian Museum.

What are your future plans?

Working on installations in Australia and Europe in particular and an art garden project in Berlin, Germany.

Reflections:

I loved my time in Tokyo. I continued to visit Tokyo and other parts of Japan and exhibit there for many years afterwards. A high point was creating a work for Echigo Tsumari. This gave me the opportunity to spend time in the beautiful landscape of Echigo to create a fuller experience of

Japan. I respond very strongly to the aesthetics and philosophies of Japan particularly the architecture, both traditional and contemporary, and gardens. My initial experience of Tokyo from the residency changed the nature of my own work and more recently the building of my own house and the creation of my own garden. I have a constant longing to return.

Neilton Clarke

Methods: Painting, printmaking, and drawing.

Residency: 1991, Itsukaichi, Nishitama, Tokyo and 1993, Tokyo.

Most vivid memory:

The density of the city, and the contrast between its downtown and outlying areas, such as the mountainous west Tokyo area.

What are you doing now?

Making artwork, writing, and travelling

Reflections:

Tokyo loco in situ so
Humming, on your map
Revolutions somewhat skirt
Shook-up waves, odd seismic slaps
A bastion to touch right down at
A realm for lights lit up
Peopled particle wonder show
Masked up it's cool to cough
Laid out all before you
Immersive, plain to see
It doth take time to fathom
Every nook and crannied tree

Dr Eugenie Keefer Bell, FRAIA

Methods: Jewelry.

Residency: 1994-1995, Monzennakacho and 2006, Takadanobaba.

Most vivid memory:

My most vivid Tokyo memory is of an extraordinary evening my husband, Robert Bell, two other guests and I spent in the home of master goldsmith, Yasuki Hiramatsu (1926-2012). Hiramatsu-sensei, wearing full traditional dress, performed *cha-no-yu* (tea ceremony) in the exquisite tatami-floored tea room of his Tokyo home, including a multi-course *kaiseki* meal beautifully prepared by his wife. Midway through the evening, he ritually changed the scroll hanging in the *tokonoma* (alcove), signaling a different phase of the experience. He served a carefully chosen range of fine sake, served to each guest in bowls selected particularly for the individual. My husband's subtly glazed bowl was made by Bizen potter Fujiwara Yu, while mine was an unusual form Hiramatsu made from folded hessian which had been electroplated in platinum. At the end of the evening, Hiramatsu-sensei stood in the drive, gently waving a lighted lantern as we were driven away, across the elevated expressways of Tokyo, back to the studio.

What are you doing now?

I left my position as Associate Professor and Head of Design and Architecture at the University of Canberra in late 2013, and have since done freelance work in architecture, jewelry and photography.

What are your future plans?

I am in the process of setting up a new studio for my practice in jewelry and photography. I look forward to future travels to Japan to inform a new body of work.

Reflections:

Living in Tokyo had a significant impact on my personal and professional life. The two residencies offered exceptional opportunities for fine-grained research and cultural immersion, with the luxury of time to investigate and reflect. My studio practice benefitted from studying extraordinary collections and exhibitions of metal work, lacquer, ceramics and textiles, from visiting historic and contemporary architecture, and from daily acts of drawing, photography and writing. Sketch models of jewelry made in the studio were developed back in Canberra and later shown in three-person exhibitions in Tokyo and Kyoto.

Having a base at the Tokyo Studio made it relatively easy to travel elsewhere in the country to visit artists and museums and to experience Japanese gardens and architecture in the context of changing seasons.

During the first residency, we were introduced to the work of writer Junichiro Tanizaki, through his slim book, *In Praise of Shadows*, a prose-poem meditation on the roles of shadows and duskiness in Japan. Tanizaki wrote eloquently of the quietude of shadow in traditional architecture, on how, within a shaded space, lacquer or gold acquire a gleaming lustre, and on the intimacy of clouds of miso swirling in a dark bowl. We were living in the then newly renovated Takadanobaba studio, with its fresh tatami floors, translucent *shoji* window screening a relentlessly urban vista. And immaculate white paper-covered sliding doors dividing the three small rooms. The space required being 'present' during moments of inhabitation, taking care to place fingertips in the door or window pulls to slide them open, and being mindful when stepping on the tatami. We purchased a few objects for dining or holding flowers, which became part of both the residency experience and the later pleasure of memory. We left Japan with a more nuanced appreciation of spatial experience, the qualities of light, and the resonance of particular objects.

Joan Grounds

Methods: Interdisciplinary art works, primarily three dimensional.

Residency: 1995, Monzennakacho.

Most vivid memory:

It is interesting to me that I have not one particular memory more vivid than another. It was all such a fantastic and wonder-filled time. I think the friends I made and still have, teaching the businessmen English in the amazingly tall office block that swayed in the wind, and the architecture of Tadao Ando. But there are so many others, I cannot isolate them as they are all so vivid in my memory they have become a part of my life.

What are you doing now?

I am doing a collaborative installation work with an Indian artist that will be shown in Tokyo in February, 2017.

What are your future plans?:

After that exhibition I will be setting up a new studio in the country here in Australia.

Reflections:

Tokyo is almost a person to me now, the memories from that residency are so vivid and real that I can smell the food in the bento box, walk into a serious shop selling tea with small amounts of green tea laid out like jewels, walk through the Ando Museum ecstatic and changed forever, laugh and

learn from the men the Australian artists all taught in English class, go to small, out-of-the-way galleries with very interesting young artists guided by my good, loyal friend Kiyoko. There are so many, many wonders in your city and culture, they are flooding back for me now, too many to record. What a wonderful opportunity that residency was. I am deeply grateful for the opportunity.

John Young

Methods: Painting, installation and public art.

Residency: 1998-1999, Takadanobaba.

Most vivid memory:

My friendship with Cai Guo Qiang, walking the streets of Tokyo together. As well as travelling with my young son Jasper (9 months old) in a Japanese pram, and how my wife and I were constantly met with amusement, surprising and warm greetings by the public. To this day, our son, now 18, returns to Japan often and speaks Japanese. It is his favourite country.

What are you doing now?

I live in Melbourne and we have two teenagers, Jasper and Charlotte. I still exhibit regularly and nationally in Australia, Germany and Hong Kong. I just completed my first solo exhibition at Pearl Lam Galleries, and an exhibition in Berlin. My main project now is a series of abstract paintings which was started in 2006, and a project involving many exhibitions concerning the history of the Chinese diaspora in Australia in 1840. This year we are also celebrating the 20th anniversary of the founding of 4A Centre for Contemporary Asian Art (in Sydney), an organisation that several artists, including myself started in 1995.

What are your future plans?

A book, together with my novelist friend Brian Castro, on the old Macau.

Sachiko Tamai

Reflections:

In retrospect, we feel so appreciative of all the efforts that Sachiko Tamai has made in setting up the studio and helping us stay in Tokyo. It is an immense effort and Australian art has benefitted greatly through the experiences and insights artists have gained. Her efforts in setting up the studio have definitely helped in shifting the Eurocentric vision that Australian artists used to hold, and that they could find an expanded vision and context for their own work.

For myself personally, during that time I saw the wonderful retrospective of Sotaro Yasui in Yokohama, and Shusaku Arakawa's Site of Reversible Destiny at Yoro Park in Gifu. And the revisit to my love of all loves, Ryoanji in Kyoto, and Korakuen in Tokyo.

Selina Ou

Methods: Photography.

Residency: 2005, Takadanobaba and 2008, Oyamazaki, Kyoto.

Your most vivid memory:

My most vivid Tokyo memory was being overwhelmed by how much there was to learn, explore and photograph in this immense and exciting city. After three months I felt I had only scratched the surface of life in Japan and I wanted to know more.

What are you doing now?

I am a photographer in Melbourne, Australia and I am raising a young family.

What are your future plans?

My goal is to continue developing my catalogue of environmental portraits in Australia and overseas and work towards creating a book in the future.

Reflections:

In Tokyo, I came to appreciate the beauty of working with others. At the beginning of my residency, I struggled to connect with potential sitters as I could not speak Japanese. Eventually, I had to ask a Japanese friend for help and they acted as my translator and cultural guide. Their contribution added to the project tenfold. From then on, I approached portraiture as a collaborative activity rather than a form of documentation.

Dr. Sean O'Connell

Methods: High voltage photography, moving image, jewelry, sculpture . . .

Residency: 2007, Takadanobaba.

Most vivid memory:

Fighting bushfires on the hills in Oita-ken with water backpack... The beautiful sense of order and respect within social structures... Tea ceremony classes... Walking through the city, endlessly... Charming people I met...

What are you doing now?

I Just finished my PhD study in Fine Arts – I am a doctor! :) Making photography and film, and contemporary jewelry. Planning to come back to Japan again (I have been back three times already...).

What are your future plans?

Planning on making very different work – like mixing together children's books, dioramas, wooden clockwork, and beautiful sunny days – to make something colourful and joyous to bring more happiness into people's days. :)

Reflections:

My residency in Tokyo was my first time overseas. I fell in love with the people-their sincerity, respect and dedication. I also fell in love with Japanese craft and design, and avant-garde music.

When I first arrived, I walked all day, every day, for three weeks. I wore out my shoes, started to find my way around, rested briefly in all the beautiful parks, and ate many, many bowls of ramen. All the food was delicious and I ate food out and cooked in the residence-to find maitake mushrooms in the supermarkets was so wonderful! My next door neighbour made me lunch one day, and I made lunch for her the next day, and somehow we spoke German in my kitchen (her English was bad and my Japanese was terrible!)

I went and worked on organic farms in Oita and Toyama. Tending chickens in the snow in Toyama, tending ostriches in Oita, and resting in Sujiyu onsen after work-very nice! I realised how different the people in the country were-earthy, honest, practical, slow, trusting, but hard to get to know. Beautiful people and a beautiful landscape. I visited countless museums, galleries, shops and venues, and started to understand the difference between art and design and craft as it is seen here in Australia, and as it is seen in Japan. It was beautiful to see how traditional heritage informs the respect for aesthetics-something that is missing in Australia. . .

I think most of all, I realise how a life in Tokyo can sometimes be very hard, strict-with too much order-but also, this makes for trust, respect, dedication, and appreciation. It is always a balance, and to be a part of such a different culture, I was very lucky.

I sometimes wish I was born in Japan. Or maybe hope that I could fall in love with a lovely Japanese woman! It is a wonderful place.

Sophie Kaln

Methods: Art and sculpture.

Residency: 2008, Takedanobaba.

Most vivid memory:

I have so many! Eating gelato at the cat-filled cafe in Kichijoji park; crossing the road at Shibuya among thousands of people; browsing the incredible selection of craft and art supplies at Tokyu Hands...

What are you doing now?

I live in New York City and continue to work as an exhibiting artist. I also run a 3D scanning business for artists and designers.

What are your future plans?

I am working on some group shows in New York and Rhode Island and will be showing large 3D printed sculptures.

Reflections:

The Australia Council residency was the most incredible luxury. To this day, artists I meet in New York express astonishment at the freedom that a 3 month residency affords. I had recently moved to New York when I did the residency, and the break from temp work was invaluable in the development of my practice. I was also in the process of transitioning from an image-maker to a sculptor and was still experimenting with ways of materialising my 3D scanned work. I used my time in Tokyo to study and

experiment with digital origami. I used Japanese software called Pepakura to 'unfold' and then print my 3D models, which I then painstakingly cut with an exacto knife and glued to create a 3D object. Although I didn't continue this mode of work (I shifted to working with 3D printing shortly afterwards, in 2010), I continue to explore the intersection of imagery and 3D form. In fact, I am on a residency in upstate New York at the moment and am working on applying decals to my 3D printed sculptures, using the same software I first used in Tokyo! That phase of experimentation continues to play out in my practice. Perhaps one day I will return to making origami-inspired sculptures...

Noël Skrzypczak

Methods: Painting.

Residency: 2009, Takadanobaba.

Your most vivid memory:

One of my most vivid memories from being in Tokyo is seeing a fantastic exhibition of Ikeda Ryoji at the Museum of Contemporary Art (MOT). Another is eating Takoyaki and drinking Sapporo beer on the busy street near Takadanobaba station on my first evening there-so delicious and so exciting to be there!

What are you doing now?

I am working on a commissioned wall work for the new Bendigo Hospital, and raising my 1-year-old son, Aki.

What are your future plans?

A solo exhibition at the Neon Parc Brunswick Gallery.

Reflections:

My residency in Tokyo was primarily for the purpose of strengthening my own personal and artistic ties to my mother's home country and its culture. During my three-month stay I joined two different *sumi-e* classes, and also took Ikebana, Way of Tea and *O-Shuji* lessons. I already had some very basic *O-Shuji* training from when I spent a year in Japan as a primary school student, and even this very small amount of training made its

impression on my professional art practice, so I figured that more extensive and varied training would be good for my practice.

As well as going to my various lessons each week, I enjoyed teaching the English conversation group once a week, exploring different parts of Tokyo on the bicycle, and going to see as many art exhibitions as I could.

My residency was also characterised by a lot of travel outside of Tokyo, to visit relatives and to explore parts of the country I hadn't seen before. My mother and sisters traveled with me some of the time. My mother staying with me in the studio meant that the television was on a lot of the time during that particular week, and because she could explain to me what was being said this turned out to be a great additional avenue for understanding Japanese culture-through tv!

The training I received by going to the various classes hasn't manifested directly in my current art practice as a visible "Japanese connection", but I never expected it to. What I did expect was that my enriched understanding of Japanese traditional composition, balance, technique, aesthetic sensibility, and use of materials would seep into the "soil" from which my artwork grows-a permanent influence that gives it depth and vigour.

Tai Snaith

Methods: Painting and sculpture.

Residency: 2009, Takadanobaba.

Your most vivid memory:

I loved walking along the canal every day. My most vivid memory was attending a very unusual wedding in a club between an artist and a dancer, after the ceremony she took a giant pair of scissors and cut her dress off in front of the guests

What are you doing now?

I am working on a large floor-based ceramic commission for a show curated by Janine Burke called *Human Animal*. My work is called "Merz Bower" and it looks at the idea of a collection of both made and found fragments and objects and experiments. The parts are arranged in such a way to suggest a bower bird with a penchant for odd, pastel, kitsch and mid-century modern objects.

What are you future plans?

I am in the process of planning a series of wall-based ceramic assemblages and reliefs that are paired with short fictional texts which I hope to have read by different people and recorded so the audience will listen to the texts rather than read them.

Reflections:

My first week in Tokyo I was overcome with emotion. I recently found videos I made during this time of my crying to the camera, which I had completely forgotten about. I felt both free and captive. I found a part of myself that had been hidden away since I was a small child. Many of the drawings and collages I made whilst I was in Tokyo still represent something very important in my practice now. I felt like my inner child was in control.

I remember reading a lot of Japanese fiction during this time; Ryūnosuke Akutagawa, Yukio Mishima, Haruki Murakami, Banana Yoshimoto and Kobo Abe. I was transported by the words of these writers to a place that I found completely fascinating. Tokyo for me presented a kind of elegant, hard-boiled simplicity in its literature at the same time as an over-saturated and stimulated madness in the city itself. I was also tempted by the pure mono-culture and history of the place; the temples, houses and gardens, even the fabrics. I travelled extensively and learnt as much as I could about the many Shinto animal gods and shape-shifters. I felt very inspired by the incredibly rich narratives, particularly about animals, that informed so much of the culture and icons throughout Japan. In some ways I felt I could associate with this more than a lot of Australian culture.

I was very surprised at first to find out I would be teaching English as part of the residency, but later found it hugely useful in my understanding of the mindset and culture, particularly the unique way of Japanese storytelling. I remember one day I set the students the task of writing a dream they had recently had and bringing it to class and reading it aloud. I will never forget some of these dreams, almost as if I had them myself.

Viv Miller

Methods: Painting, drawing and animation.

Residency: 2009-2010, Takadanobaba.

Your most vivid memory:

I learnt to look up while walking through city streets because, unlike most of Australia, the street shops continue up the buildings.

What are you doing now?

Same stuff! Making art.

What are your future plans?

Just more art making, really. Whichever way I can.

Reflections:

My time at the Tokyo studio was wonderful. I spent the first two of my three months there just walking around Tokyo, and only sat down to make my own work during the last month. My days would typically look like this: it was winter while I was there, so I would put on my big jacket, find my *Suica* subway and rail pass, and venture out of the studio into the narrow, compact streets of Tokyo, and journey to find some gallery or museum. In between my destinations, the streets offered plenty of sights along with bowls of *soba* and *ramen* noodles. And unlike many of the coffee snobs before me, I developed a taste for the cans of syrupy hot coffee on offer from the vending machines that seem to align each street

at intervals of ten meters. I even worked through the various brands, but truth be told, could never tell one flavour from another.

It's easy to get lost in Tokyo. I was often struggling to find my destination. I think visitors are used to assuming that a city automatically forms into rectangular blocks, but the streets and buildings of Tokyo behave less predictably, amassing in a seemingly organic tangle. And they don't use a street address system that's quite as sequential and straight forward as Australia's. I was relying on the well-thumbed street map of Tokyo I took from the studio. So, in city whose citizens long ago adapted to the mobile phone with all its various digital apps, I didn't just look like a tourist, but a visitor from some bygone age.

Jenny Watson

Methods: Post-conceptual painting.

Residency: 2011, Takadanobaba.

Most vivid memory:

Working in the small tatami mat flat provided by the Australia Council and taking a walk after completing work to have lunch, dinner or visit an exhibition.

What are you doing now?

Preparing for an exhibition in Vienna in November 2018.

What are your future plans?

A residency at the American Academy in Rome in January 2019.

Reflections:

I enjoy returning regularly to Tokyo and Japan to, visit friends, look for fabrics to use as a support for paintings, as well as pigments, papers, paints and timber supports. I particularly enjoy looking for pigments and finding subtle new shades to feed into my work. I also observe daily life and inevitably have experiences that I can use as subject matter.

There are always interesting exhibitions by local artists, and exhibitions at the various art museums in Tokyo and in adjacent areas. Whilst resident in Takadanobaba I walked the streets of this locality that were of the

scale typical of Edo-era Tokyo, and experienced daily life, and enjoyed encountering moments from the past.

I have been fortunate to have visited Japan on many occasions for over thirty years and I was included in an exhibition that marked the Bicentenary of Australia that was curated by Judy Annear entitled *Edge to Edge: Australian Contemporary Art Exhibition to Japan* that travelled to the National Museum of Art, Osaka, Hara Museum, Tokyo, Nagoya City Museum, Nagoya and Hokkaido Museum, Sapporo over the course of 1988 and 1989.

In 2003 I had a small solo exhibition entitled Child's Play at the Yokohama Museum of Art for which I exhibited paintings on unstretched fabric and a set of prints in a specially made wooden box of images inspired by recollections from childhood.

My residency in Takanobaba was followed by an exhibition in October 2012 in the new space opened by the Tomio Koyama Gallery in the Hikarie 8 space, Shibuya entitled *Other Lives*. It was a series of paintings on hessian accompanied by a text panel and a room of small water colours. The hessian paintings saw me imagine myself in other people's lives. It was an honour to exhibit with such a prestigious gallery in Tokyo.

Philip Brophy

Methods: Film, video, music, writing.

Residency: 2011, Takadanobaba.

Your most vivid memory:

Watching Tokyo change in the months following 3/11

What are you doing now?

Working in film, video, music, and writing.

What are your future plans?

More of the same.

Reflections:

January 1984. I'm standing in front of the large swimming pool at Toho Studios, used for all the Tokyo Bay dioramas for over 15 Godzilla movies. I thought Godzilla would be enshrined in Japan at this time, but hardly anyone seemed to remember him. Japanese cinema seemed dormant, attempting to be arthouse-friendly after 30 amazing years of cursive and wild moviemaking post WWII. Contemporary art at the time similarly seemed aimless, lazily swimming in pools of Nihonga pictorialism save for the aberrant likes of King Terry and Hibino. Manga and anime were the only signs of life: 1983 was the dawn of the OVA-era which would pave the way for much vitality in art and cinema as well as waves of anime/manga appreciation.

September 2015. I'm standing in front of a kitchen wall inside a house within the Exclusion Zone of Fukushima. ChimPom have instigated an incredible series of site-specific installations by Japanese and non-Japanese artists inside evacuated residents' houses. Walking around Fukushima is like being inside an anime background painting before the cel is overlaid, containing the painted characters. This stillness belies an overpowering aura which reminds me of the still waters of the Toho pool. I look at a strange image on the wall: it's like a frosted earthen diamond. It takes me a while to realize that it's a calendar photo of Mount Fuji, perfectly mirrored in Lake Kawaguchiko. The photo has been dislodged by the 3/11 earthquake, so that it hangs at a 90° rotation. The Toho pool and this calendar of Fuji are examples of 'land art' made without humans. I don't encounter these occurrences anywhere else in the world. It's why I always return to Japan.

Arlo Mountford

Methods: Digital art and moving image.

Residency: 2012, Takadanobaba.

Most vivid memory:

Waking up to snow on the rooftops outside our window in the Takadnobaba apartment.

What are you doing now?

Studying, practicing, teaching, raising children!

What are your future plans?

I'm currently halfway through my masters, so am focusing on this for now.

Reflections:

Tokyo in 2012 for me, was a break of sorts. I'd been working hard on numerous exhibitions up until this point and I needed to immerse myself in something familiar but different. I already knew I would enjoy myself, so I arrived primed to focus on some work I'd been keeping in my back pocket. I painted! Not something I would normally do but do enjoy. One painting a day-they were for me not for anybody else! I also worked out some other zen-ish tendencies again-for me not for anybody else! I travelled a lot, but came to miss the embrace of Tokyo, the warmth of a busy Shinjuku Station, the Yamanote line. Bars, bars which can only exist in Tokyo. I remember a bar where the owner would eaves-drop on our

conversation then adjust the music to suit – it sounds strange, even creepy but it was an open deliberate exchange, a perfect evening punctuated by moments of 1990's nostalgia.

My friend Nick Selenitsch came to stay, he bought a café magazine written in Japanese we chose by the pictures and followed the map discovering parts of Tokyo we wouldn't normally visit on foot. I remember drinking the strongest coffee ever whilst eating a doughnut with sickly sweet green camouflage icing.

I also spent a lot of time in The National Museum of Western Art, designed by Le Corbusier. Emily and I photographed it from as many angles as we could. Inside its houses were many works by the male masters of modernism; Courbet, Monet, Van Gogh, Picasso etc. Later, once I returned to Australia I would animate it exploding, fracturing, collapsing as I combined it (mashed it), with the climactic scene from Shiro Ishimori's *Galaxy Express 999* (1979) and images of works by the Japanese Avant Garde and the Gutai Group.

Nick Rennie

Methods: Design – furniture, lighting and homewares.

Residency: 2012, Takadonaba.

Most vivid memory:

As someone who had already been to Tokyo quite a number of times before my residency, my favorite memory is related to living in the area I did. I was blown away how many children were playing in the streets. Walking with their friends to the park to play until dark. Just like I did as a child, but something now that isn't so possible here in Australia. It made me think that Tokyo was, in fact, one of the best places in the world to be a child.

What are you doing now?

Working with a select few of the world's best furniture manufacturers in Europe and Japan

What are your future plans?

Continue to work on new projects and looking for new partnerships.

Reflections:

I am lucky that Tokyo is deeply entrenched in to my life. I am about to visit next month during design week for the 37th time. It just seems to resonate with me on so many levels… The respect that the Japanese culture has for creativity I find is unlike anywhere I've ever been. And the friendships I have made there are life-long. These friendships are my real Tokyo. A mix

of Japan's finest creatives, who like me, live for our freedom of expression. Supporting and inspiring each other through our work. We speak a similar language and dream a similar dream. This influence has possibly been the strongest on both my career and my life in general. A mix of technology and tradition.

Tarryn Gill

Methods: Painting, architecture, craft, photography, sculpture, design, prints, fashion, digital art.

Residency: 2012, Takadanobaba.

Your most vivid memory:

Summer nights walking alone through the streets of Shinjuku and Shibuya amidst the blaring lights and sounds.

What are you doing now?

I'm making artwork and living in Perth, WA. My recent focus has been making soft sculpture works and also some theatre collaborations.

What are you planning next?

In the short term I plan to continue to develop work here in WA. I would love to return to Japan for a project. I often dream that I'm there.

Reflections:

I undertook the OzCo Tokyo residency at a time that was incredibly pivotal for me, professionally and personally. I was attempting to begin a career as a solo artist and after many years of working in collaborations I wasn't sure what that looked like. I didn't know what I wanted to make and I was struggling to find confidence in myself and as an artist. The opportunity to spend three months at that time exploring a new city and reflecting upon myself and my career was an invaluable experience.

Tokyo was an ideal place to look for inspiration because I'm a big fan of Japanese aesthetics and pop culture. I spent most days exploring different parts of the city on foot, frequently coming across things that filled me with joy or wonder. It was enriching to spend time seeing artwork, visiting museums and meeting other artists and curators who were working in Tokyo. During this time, I had the opportunity to assist another artist in building their installation for an exhibition. Through this experience I began to understand how much I loved working with my hands and that making objects could be my new direction. This was a huge revelation to me after many years of predominantly working on photo or film-based projects. Since this residency, and over the past 6 years, I've been slowly building a studio-based practice and have been making hand sewn, soft sculptural works. I'd say that all of the residencies I've undertaken over the years have helped to shape who I am and the work I make profoundly. Receiving the Tokyo residency was a great privilege and I'd love for every artist to have the opportunity to take time to enrich their practice in that way.

Karl Logge

Methods: Undisciplined art-practices and radical design interwoven with soundscapes, video projection, installation, livish-art.

Residency: 2012 –2013, Takadanobaba.

Most vivid memory:

Snow for the first time in my life, arriving at the sea in Kamakura as the sun set, catching trains, wandering the arcades passing the new year in loud and busy temples and quiet and empty ones, sleeping so deeply that it felt almost impossible to wake up, waiting for something big to happen.

What are you doing now?

Since Tokyo I have not made many more works or projects. Instead, I ended up moving from Australia to a small island in the Mediterranean Sea where I have been for the last few years learning the art of ancient weaving from the last Master of Bysuss Chiara Vigo and trying to finish my PhD on the weirdness of the future of design and human planetary inhabitation.

What are your future plans?

What comes next is a big question at the moment. There are a lot of unknowns to the future of what I call my art practice and also what I call life. I hope that I can bring together the different experiences, time-scales and ways of working that don't seem to fit with each other. I pretty sure that I will still be weaving, maybe later even beginning to pass to others what I have had passed to me. I would like to start painting seriously as it's been a dream for a long time now.

Reflections:

The Tokyo residency came at a very particular moment of my life, a real turning point between how I used to work as an artist and a totally new way of living. More than anything else this makes my residency in Tokyo a special experience for me, even if the residency itself marks the end of my career in many respects.

I was in Tokyo for 21/12/2012-that famous date that everyone was talking about at the time as the end of a long cosmic cycle and a moment of a new awakening-a rebirth day of sorts. Of course, nothing cataclysmic or extraordinary really happened, at least in any outwardly obvious way-I remember thinking that it could be momentous but instead I found myself in an intense lethargy, hibernating like a creature in a cocoon.

My original proposals for the residency project all went out the window, so to speak, and yet the result has been that what I created in Tokyo continues to be something I reflect on a lot and is as important to me as any other work that I have realised without actually exhibiting the work itself.

I heard that the residency itself might be drawing to a close, another sign that an era was coming to a close. And so, somehow these different aspects came together for me by looking at the concept of nothingness. I tried many different things and had many different ideas but what I consider to be the final work to come out of my time in Tokyo is a series of videos that record the sun rising through the window of the apartment. It seems an almost unchanging image but there are subtleties that indicate time is passing-the invisible hand of the great painter tracing the most abstract and delicate lines down that rice-paper screen.

If I ever get to finally show this work one day, these videos will be projected onto a reconstruction of that window and a small space measured out in the same number of tatami mats that made up the small Tokyo studio. I would like it to be an intimate and utilitarian, nostalgic and comfortable, but also slightly claustrophobic space that if you stay still and wait a little while it might enter you, make you sleepy or event puts you to sleep entirely so that you start to dream and travel through an enormous and complex city that has been built somewhere between nowhere and nothing.

Newell Harry

Methods: Cross disciplinary: photography, installation, drawing, printmaking and combinations thereof.

Residency: 2013, Takadanobaba.

Your most vivid memory:

The ever-present contrast between old and new. For example, attending Kabuki theatre one evening, then, the following morning, blasting off at some 300 clicks per hour on the Shinkansen to Aomori. In another example: older women, typically dressed for an important formal occasion in beautiful, floral Kimono, jostling past young women in 'punked-out' kimono appropriations, safety pins and dyed hair on Shibuya's streets.

What are you doing now?

Currently (November 2018), I am in Paris undertaking a Fellowship at Atelier Villa Vassilieff (Montparnasse) with Bétonsalon and the Pernod Ricard Foundation.

What are your future plans?

Living one moment to the next, one day at a time.

Reflections:

The humble beauty of traditional tea ceramics, as well as other customary art forms continues to have a profound effect on my thinking on aesthetics and materiality. From paper making to Kimono fabric design and Edo

woodblock printing, the contrast between these older traditions and the 'contemporary' ways they are re-invented and appropriated by new generations in fashion, anime or Cosplay, continues to captivate me. As does the more intimate and porous understanding of relationships between nature and culture, as can be experienced in the restrained, subtle beauty, of Japanese gardens. In my many travels to Tokyo (and Japan more broadly), I've grown to feel far more at home with the Japanese sensibility towards these contrasts, which I find far more holistic and fluid than in the West with its engrained need to separate and organise things along binaries. The cultural acceptance of 'imperfection' and the transience of life and matter in *Wabi-sabi* is one case in point among many that continues to greatly impact my thoughts and life as an artist.

Dr. Megan Walch

Methods: Painting, architecture, craft, photography, sculpture, design, prints, fashion, digital art, and other categories (painting and drawing).

Residency: 2014, Takadanobaba.

Your most vivid memory:

Feeling like Craig Schwartz (the unemployed puppeteer) in *Being John Malcovich* on the scaled down version of the 7½ floor.

What are you doing now?

I am on an artist's residency on Jeju Island, South Korea.

What are your future plans?

After my time in South Korea I will return to full-time studio work in Tasmania to prepare for exhibitions.

Reflections:

Tokyo and I are in love but we will never fully know or understand one another. Our labyrinthine affair began below ground level and continues into the sky; wired together with electrical black spaghetti, knitting alley to apartment to high-rise. We are chaperoned by the cheery cheep cheep of traffic lights and the ever present call of glossy black ravens. Our hot coffee comes from vending machines as we hum along to the Astro Boy earworm of Takadanobaba Station. A replica of a Viking ship delivers our sushi at lunchtime with a loud Piiiiing! We have blossom maps, blossom forecasts,

and blossom sweets as we watch five men pruning ancient black pine trees with tweezers. Today the news announced that chilled soba noodles are now in restaurants to herald the arrival of the warmer weather. As we board The Snow Rabbit Express to Kanazawa – we say *ichigo ichie*-this is a once in a lifetime encounter.

Sarah Berners

Methods: Sculpture and Photography

Residency: 2014, Takadanobaba.

Most vivid memory:

So many! The majestic Sumo wrestlers at Ryogoku Stadium, the streets of Shibuya bustling with zombies on Halloween night, 21_21 Design Sight's phenomenal exhibition *Image-Makers* and soaking in a wooden tub at my local *sento* bath as a storm brews at dusk.

What are you doing now?

I am currently working from a home studio in Fitzroy and exhibiting regularly with Lindberg Galleries in Collingwood, Melbourne.

What are your future plans?

I am working toward a new solo exhibition in 2017. I am still working with sculpture and photography and am enjoying collaborating with photographers, make-up artists and other creatives to realise images.

Reflections:

My 2014 Australia Council Tokyo Residency marked my third visit to the spectacularly strange and enigmatic city of Tokyo. Rather than focusing on the production of artworks in my tatami floored apartment in Takadanobaba, I aimed to roam and explore as many nooks, crannies and 10th floor buildings as possible throughout the course of my three month

tenure. The impact and effects of this time on me are difficult to outline in words and yet a visual encyclopedia of images spills forth in my mind when I recall my time in Japan. I understand and recognise the manifestation of so many fractals of experience within my art practice today and generally within myself personally two years later.

Having insatiable curiousness for themes of costume, mask and masquerade, Tokyo opened up into a living breathing spectacle for me to explore. From the idiosyncratic fashion stylings of the Harajuku set to the garb and ceremony of the Sumo and the Kabuki theatre actors, cosplay characters and Geisha, I found myself cataloguing an abundance of new silhouettes, textures, forms and physiognomies. The unique sense of fantasy, adornment & transformation of the body was a huge influence on my practice as an artist, encouraging me to initiate research into artists such as Kitagawa Utamaro, Katsushika Hokusai and Makoto Aida.

Tokyo remains to be my favourite city in the world. From minimalist Zen temples to the chaotic futurism of the city's hubs, it is full of surprises, sub-cultures and intrigue. I can't wait to return again soon.

Akira Akira

Methods: Installation.

Residency: 2014 –2015,Takadanobaba.

Your most vivid memory:

I went to a ramen restaurant Tsuta in Sugamo. The intricacy of the broth was absolutely incredible and was by far the most vivid memory from my time in Tokyo. So it happens, they became the first ramen restaurant to receive a Michelin star in 2015.

What are you doing now?

After completing my residency in Tokyo, I moved to New Plymouth, New Zealand where my partner recently took up the position of assistant curator at the Govett-Brewster Art Gallery. I've been here since, also working part-time at the gallery and trying to continue develop my art practice.

What are your future plans?

Since my Tokyo residency, I have been more active in applying for exhibition and residency opportunities in Japan. Though so far unsuccessful, I'll keep at it. At some point in the near future, I hope to start a doctoral degree.

Reflections:

Growing up in Kobe, Tokyo had always been an elusive presence and I never had much interest in visiting. Out of the blue in early 2013, however, I was invited to participate in an exhibition in Tokyo – the opportunity

to exhibit my work in my home country for the very first time. My first ever visit to Tokyo was during April that year to inspect the gallery. The visit lasted only seven hours but a more substantial visit and the fantastic experience of the exhibition followed in September. So, I was ecstatic to find out few months later that I was successful in securing my place in the Tokyo studio residency for 2015.

Two years on, I am writing this in a small regional town in the west coast of New Zealand's North Island. I feel like the momentum that I had – to which Tokyo was absolutely central – has ground to a halt. I'll gather more momentum and hope to return to Tokyo and elsewhere in Japan so that my Japanese art life can be revived once again.

Wendy Teakel

Methods: Painting, sculpture, drawing.

Residency: 2016, Takadanobaba.

Your most vivid memory:

I was in the East Garden of the Imperial Palace around lunch time. Two women in traditional kimono were having a conversation and picnic on the grass under a blossom tree. They were in their own world and I could have imagined I had stepped into another era if it were not for the people in contemporary dress around them taking pictures of blossoms on their smart phones. The juxtaposition of the women in traditional dress under the blossom tree with others in contemporary dress and the ubiquitous I-phone seemed to epitomize the complex intertwining of desire to balance tradition with contemporary life within Japanese culture.

What are you doing now?

I am a full time academic and Head of Sculpture at the Australian National University, School of Art and it is a constant juggle of time between full time employment as an academic and my own creative practice as a professional artist.

After spending time in Japan this year I returned to my studio at Murrumbateman, NSW to make work for the exhibition *Different Cloth/ Common Threads* with David Jensz at the Goulburn Regional Gallery and to make some sense of my time in Japan. Mid-year I returned to my role at the University. The works I made for this exhibition speak of Australian landscape but my time in Japan has influenced the work.

There are sparse uncluttered aspects to the work which I think has been influenced by looking at Japanese landscape painting on screens and scrolls. Two things occurred while in Japan. I was struck by the differences in spatial considerations evident in Australian and Japanese culture. I spent time studying the concept of *Ma* in Traditional Japanese painting and gardens and I was interested in this in relation to Australian landscape and how it could be applied.

What are your future plans?

Another part of Asia I am attracted to and influenced by is Thailand and I will return there in early 2017. While in Thailand I will be exhibiting in a works on paper exhibition in Chiang Mai and Chiang Rai which is a collaboration between academics and alumni of Chiang Mai University and the Australian National University. The works exhibited (still to being made) will reference pieces developed on a residency in Urada in Niigata Provence earlier this year. I spent two weeks in Urada staying in Australia House under the auspice of the Australian Embassy in Tokyo and the Echigo Tsumari foundation. The rural tranquility was a contrast to the bustle and pace of Tokyo. When I arrived in Urada snow covered the ground and in the two weeks I again had the pleasure of seeing the Sakura trees blossom. In this area of Japan there are many traditional buildings pertaining to farming and rural life. I explored the foot print and idea of the building (or trace of humanity) in relation to the elemental forces such as snow and earth through works on paper using scorching (pyrography), collage, pastel and gouache. I will apply this technique to observations of Lana culture, the traditional culture around Chiang Mai. Although in Thailand the dominant elemental forces will change from snow, field, earth and sky as they were in Japan to heat, humidity, smoke and haze.

Reflections:

Arriving early evening at Narita, catching the train to Nippori and Takadanobaba walking to the Studio dragging a large suitcase was easy, and bode well for finding my way around Tokyo and Japan. The next day

I visited the Meiji Shrine, a place I remembered from visiting in 2000. It was raining slightly, keeping many away from the gardens and the sense of tranquility there was palpable. Buoyed by my ability to navigate Tokyo so far, I set off confidently to find the Sekaido art supply store in Shinjuku, but nothing prepared me for the confusion and teaming mass of humanity at Shinjuku station. After a frustrating couple of hours taking wrong turns I gave up and retreated to the studio at Takadanobaba. Armed with countless downloads of maps and Apps about Tokyo on my I-pad I tried again and this time was successful at navigating the confusion of Shinjuku station and the endless department stores that surround it to reach fresh air and art supply nirvana.

Sekaido is a beautifully laid out store over several levels where you can purchase any kind of pencil, brush, ink, paint or crayon coupled with well-crafted painting boards, canvases and superb papers. It was visually delicious to see the art supplies laid out in their rainbow assortments. Armed with supplies of tiny wooden boards, gouache and an assortment of other goodies I trekked home to the studio.

While in the residence I spent time making small drawings and gouache paintings. The studio room furnished with a desk was a Tatami room. It seemed safer to mix paint and make art at the tiny living room table on the utilitarian linoleum floor. This required an ordered and meticulous set up of a making space and protecting furniture and surfaces with layers of news print retrieved in neat bundles from the recycling room on the ground floor of the building. Japanese take recycling seriously but that is another story. At meal times the art works would be neatly packed away and news print folded. This layering of a making space upon the living space was a new thing for me as at home I have a large 12 x 9 metre studio which I can walk into ready to make and leave when I choose. I usually work at a much larger scale than the living room table so it was an interesting challenge to try my hand at small works and to allow the influence of Japan to seep into my practice. The works produced reflect the pulse and rhythm of Takadanobaba keyed to colours observed and gridded to reflect the ubiquitous apartment blocks stretched across the view from my window.

I visited many temples, art museums, shrines, palaces and gardens while in Japan and traveled as far south as Mayayama stopping at Naoshima,

Teshima and Kyoto to visit all the usual suspects. The Teshima museum with its gentle play of water and air in space, the floating Tori at Mayayama and the Royanji Temple zen rock garden at Kyoto remain favorite spaces. I also visited the peace museum and dome at Hiroshima which was a very moving experience. As a Westerner I was humbled and deeply moved as I imagined the human suffering that had occurred. Hiroshima is a beautiful and very modern city, but sadness sits deep within its bones.

Water in Japan is abundant and its elemental nature seemed simultaneously dominant and mutable, manifest through swirling snow storms, steaming rain and rapid flowing rivers. It transforms to a cultural utility as vehicle to transform the profane to the sacred as one washes mouth and hands on entering a temple. Drinking velvety green tea in a traditional tea house sees water as the means to paying attention to the ritual and introspection. However, water in Japan also lends itself to hedonistic luxury in the form of the *onsen*. The traditional bath house takes many forms from picturesque ponds with carefully crafted views and impeccable gardens to drab utilitarian affairs of steam and monotonous tiles in hotel basements. Either way the process of washing oneself with care and entering the steaming water-sometimes too hot-is euphoric and totally addictive.

Water as elemental force has done much to craft the topography of Japan and is in contrast to that of Australia where different forces dominate. Japanese myth and art is populated by dragons, elemental creatures of air and water. I have never thought there could be a dragon in Australia. The landscape and elemental forces don't seem to lend themselves to the creation of this sort of mythological beast. While I was in residence at Urada, a small village in Niigata province I was struck by the beauty of the landscape. This area has been farmed for thousands of years although humans appear to have made little impact on its wild nature. Calm sunny days could change petulantly into boiling storms while sun lit and snow-capped mountains could be erased from view by swirling tendrils of mist and cloud. Watching the mountain just near my residence disappear within minutes and the drifts of golden daffodils pale under an eerie light I was convinced there must be a Dragon! This landscape was capable of manifesting such a fabulous beast to the human imagination. Our mythologies and beliefs are the things that make us human and also different at the root of our soul.

These are just a few of the impressions I formed in Japan. I always felt safe and I felt the Japanese to be reserved as a people but friendly and kind. Japan had nestled into its own corner of my heart and I hope to return soon and often.

Dr Christopher Headley

Methods: Installation artist.

Residency: 2016, Takadanobaba

Most vivid memory:

The main purpose of my time in Tokyo was to see as many exhibitions and visit as many galleries as possible. The exhibition that stands out in my mind is *Dialogue with Trees* at the Tokyo Metropolitan Art Museum.

What are you doing now?

Planning and applying for funding for my next show.

What are your future plans?

If all goes according to plan I will be installing new work in the vault of the Former Bank of Japan, Hiroshima, one of the few buildings to survive the atomic bombing and which is now part of the Memorial Peace Museum, in August 2017.

Reflections:

I recall one person saying to us some years ago: "every building in Tokyo is a work of art"; a friend who visited Tokyo briefly said: "Tokyo is so ugly." They may have been expressing their aesthetic preferences, but I suspect each was visiting a different part of town. Of course, it is matter of a few minutes on the very efficient subway system to change your environment entirely; even different exits from the subways open completely different

urban prospects. Depending on the gallery we are aiming to visit, we pass through environment of stunning towers, grim urban development or pockets of funky or elegant spaces.

We amble along from a gallery to a museum to a shrine. There are many private galleries which stage non-commercial exhibitions. In one such case. the woman who owns it has been collecting ceramics for some 40 years and we were expecting a survey of that. Instead, the basement space in a stunning tower was occupied by an exhibition of work by the renowned Kyoto based artist, Yo Akiyama, with works collected from various sources. It was quite astonishing-vast scale earthenware polished with graphite or lined with silver. And not a piece from the collection, even though there was an interesting one that illustrated the entry of that gallery in an art guide book we had. We asked an attendant who said; "oh, I have never seen this one before". She also explained that various items from the collection are displayed during breaks between special exhibitions. That's Tokyo for you!

Printed in the United States
By Bookmasters